ANONYMOUS WAS A WOMAN

MIRRA BANK

ST. MARTIN'S GRIFFIN

NEW YORK

REPRINTS OF BLACK AND WHITE ILLUSTRATIONS:

p. 17 (bottom), "G is a Girl," *Stories and Rhymes for Children, Part I,* 1838.
From the Collection of Old Sturbridge Village, Sturbridge, Massachusetts.
p. 28, "The Little Sampler Worker," by H. Albert Anker. The Bettman Archive.
p. 50, "Piano Playing Scene." *(Courtesy Kenneth M. Newman, Old Print Shop, New York City)*
p. 63, "A Quilting Party in Western Virginia," *Gleason's Pictorial,* October 21, 1854.
Library of Congress, Washington, D.C.
p. 84 (top), "Empire Clothes Wringer Ad," ca. 1860. *(Courtesy American Antiquarian
Society)* Photo: Todd Smith.
p. 84 (middle), "Frontispiece," *The American Woman's Home,* 1869. From the Collection
of the Worcester Historical Museum, Worcester, Massachusetts. Photo: Todd Smith.
p. 84 (bottom), "Ad for Morrill's Evaporator Cooking Stoves, Flat Irons & Nurse Lamps,"
ca. 1860. *(Courtesy American Antiquarian Society)* Photo: Todd Smith.
p. 93, "Waiting," by E. A. Abbey, 1875. Library of Congress, Washington, D.C.
p. 109, "The Patchwork Quilt," by E.W. Perry, 1872. The Brooklyn Museum.
p. 119, "Harriet Powers." *(Photo courtesy of Museum of Fine Arts, Boston, Massachusetts)*
All other black and white illustrations are from the
New York Public Library Picture Collection.

*Library of Congress Cataloging-in-Publication Data
Bank, Mirra. / Anonymous was a woman.
Bibliography: p. 127
1. Folk art—United States—History—18th century.
2. Folk art—United States—History—19th century.
3. Women artists—United States—Biography. / I. Title.
NK806.B36 / 745'.0973 / 79-16300
ISBN 0-312-13430-4*

First St. Martin's Griffin Edition: September 1995
10 9 8 7 6 5 4 3 2 1

Contents

FOR RICHARD

ACKNOWLEDGMENTS

Anonymous Was A Woman *began as a film and became a book.*
Consequently, there have been many skilled, hardworking, and
generous people who helped at every stage of both projects. I regret that
space prevents me from thanking them all individually here, but each
has my deep appreciation.
I am very grateful to Channel 13, WNET-TV in New York, and to
Perry Miller Adato, executive producer of "The Originals: Women
in Art" for commissioning me to produce and direct Anonymous Was
A Woman *for public television. The following people, too, deserve*
special mention for their generous contributions of time, advice and
materials: Betty Ring, Professor Dan Throop Smith, William E.
Wiltshire III, Joel and Kate Kopp of America Hurrah Antiques,
Nancy Druckman of Sotheby Parke Bernet, Allison Eckardt of
The Magazine Antiques, *Sarah Swift and the curators of Old Sturbridge*
Village, Mary Black and Mary Alice Kennedy of the New York
Historical Society, Susan Burrows Swan of the Henry Francis du Pont
Winterthur Museum, and Ira Bartfield and Fran Gugliotti of the
National Gallery of Art. I am particularly indebted to Marsha
MacDowell and Kurt Dewhurst for their sharing of sources, research
and written materials on American women folk artists, and to
Leslie Pockell for his sound advice.
My thanks for their valuable help and encouragement to
Tom McDonough, Janet Swanson, Marjorie Rosen, Todd Smith,
Alison Blank, Jeff Elzinga, Paula Reedy, John Cushman, Gordon
Marshall, Susan Moldow, Martha Saxton, Bob Sklar, Patty Williams,
Karen Goldfarb, Geri Ashur, Peter Herman, and Ellen Hovde.
And special thanks to Sara Bershtel, who first had the vision to see
the film as a book—my editor, friend, and touchstone.

Mirra Bank

Preface

Revolutionary when it first appeared, this book has become a classic. As unassuming in its artfulness as the art it presents, *Anonymous Was a Woman* made us appreciate the samplers, needle pictures, watercolors, and quilts of our American foremothers, made us see the beauty of objects which at that time were not so cordially received as art. The visual material Mirra Bank reproduced and the wise, funny, haunting selections from women's diaries and letters that she printed alongside them showed us something about women's lives we hadn't known, something it enriched us to know, and we loved the book for it. We have gone on loving it and reading it. *Anonymous Was a Woman* has never been out of print since it was published in 1979.

Like the patchwork quilt it celebrates, it is made of bits and pieces—pastels and watercolors, samplers and crewel, narrative works and geometric, formulaic and realistic, pictures of people courting, posing, working, and mourning, pious sentiments and fanciful scenes, farmyards and allegory. An Emily Dickinson poem about marriage is placed near a laconic record of a nineteenth-century woman's daily tasks. Practical advice from Lydia Maria Child ("Buy your woollen yarns in quantities from some one in the country, whom you can trust.") is juxtaposed with instructions on how to do a stencil painting on velvet (keep the paints moist). The down-home praise of the creative process by Aunt Cynthy, who turned with relief from the turmoil of childcare to the clarity, the "reason" of her quilting squares, is amplified by the folk aesthetic of Aunt Jane, who compares piecing a quilt to living a life: "The Lord sends us the pieces, but we can cut 'em out and put 'em together pretty much to suit ourselves, and there's a heap more in the cuttin' out and the sewin' than there in the caliker."

In some of my favorite parts of *Anonymous*, Mirra Bank documents the lives of artists of works reproduced. It is a treat to have Mary Green's notation on June 30, 1804, of her intent to start her embroidery picture of Liberty underneath the glorious finished product. It is fascinating to read about the romance of Miss Willson and Miss Brundage, the one a painter, the other a farmer, and to see examples of Miss Willson's work. After we've enjoyed the watercolors of Deborah Goldsmith, who made a living as a portraitist, the glimpses we get in letters of her courtship by a client, her marriage, her early death in childbirth break the heart, like glimpses of parrotfish seen through the water.

In the glory days of the women's movement, on the crest of which *Anonymous* appeared, women's creativity was discovered and celebrated in new places—in the humble arts of the household and in decorative arts as well as in canonical art and literature. The brilliantly chosen title was a stunning and somewhat taunting revelation: "Anonymous was a woman!" Anonymous may still be anonymous, but thanks to this lovable book she is no longer invisible. We can imagine her life—or rather, her many lives. We know that she was sometimes a girl, testing her powers and proving her love for her parents in a sampler. We know that sometimes her heart sank when she looked at her tall father and thought about how many stitches it took to make clothes for him. We know that sometimes she entered into marriage with trepidation and considered it a scary proposition to give up the protection of her parents for the protection of a person she hardly knew. We know that sometimes she regretted having married and found her own soul again only in her needlework. We know that at least once she apologized to her future husband for her false teeth and that when her husband died she often felt she had lost the best companion of her days. In short, we know that behind the unsigned masterpieces of folk art there were dense, complicated, aggravating, and satisfying female lives.

Returning to the book now, when its original shock has largely been absorbed and when folk art is hardly marginal, I am struck by its enduring charm. I am also struck by my own envy of these eighteenth- and nineteenth-century women's lives in which creativity seems woven through days of refreshing predictability. As I browse *Anonymous,* my fantasy of a good time becomes sitting around the quilting frame with my neighbors Molly and Sally and Eliza and gossiping while we stitch somebody's wedding quilt. Wherefore this late capitalist nostalgia for days of washing and baking and applepicking interspersed with days of sewing? Does my own work seem abstract? Apparently. Isn't the Internet community enough for anyone? Apparently not.

In a related fantasy, I imagine that these bygone women did a better job of combining creative work and the work of childrearing and housekeeping than we do today. How come they get to put their children to sleep under quilts they've made and we have to drive half an hour between our homes, where our kids are cared for by sitters, and our jobs? How come so many of us feel we can't have children at all if we have a career? How come we've almost evolved into two classes, the baby-having class that doesn't work and the working (middle) class that increasingly doesn't have babies?

Mirra Bank warns us in her smart introduction against being fooled: few of the painters were able to keep up their art after marriage. But I still imagine women who turned from rocking the cradle to painting miniatures, and, in the case of some of the quilters, the intertwining is documented. What appeals to me more than anything are their stolid records of continuing effort: Day 1 Worked on quilt, Day 2 Ditto, Day 3 Ditto, Day 12 Finished quilt. Their patience and commitment to

slowly achieved goals seem virtues from the past, enabled if not enforced by a slow-moving culture. Then they could be taken for granted. Now, under pressure from a culture of instant effects, they seem incredible luxuries.

If the bygone lives sketched in this book seem more coherent and well integrated than ours today, I have to remind myself that seeing the coherence of lives is the work of the artist, and if I see the coherence of theirs, it's thanks to Mirra Bank. Someday a future Mirra Bank will make a book about our lives today which cleverly shows the ways in which we express and sublimate our female creativity. And yes, it may have to do with computers, and it may have to do with gardening or scavenging, with entertaining or fundraising or planning trips or making a living or getting about the streets of town or even fitness, but it will surely suggest to us the beauty and inner logic of something we would laugh at now if anyone told us it was art.

<div align="right">

Phyllis Rose
April 1995

</div>

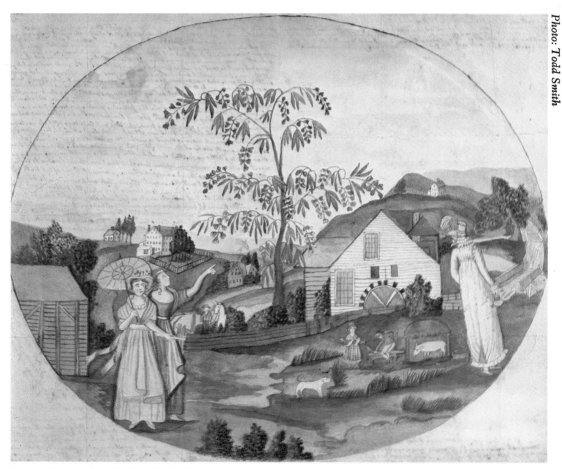

Eunice Pinney, *Two Fashionable Ladies,* watercolor

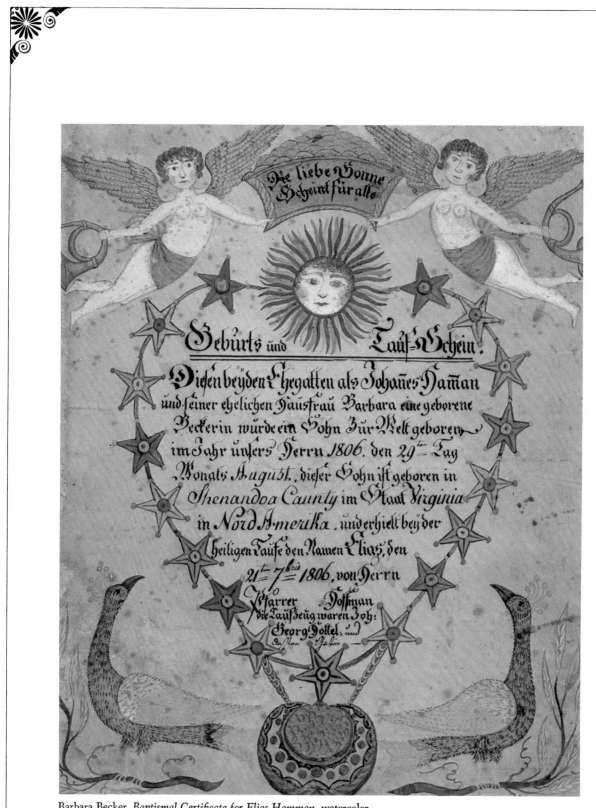

Barbara Becker, *Baptismal Certificate for Elias Hamman*, watercolor

Introduction

In the late 1970's I spent months on the road researching a project that would become, first the film and then the book, *Anonymous Was a Woman*. At that time the creative legacy of eighteenth and nineteenth century women mostly languished in university libraries, museums, archives, and private collections. Little art or writing by everyday women had come to public attention, and while the dearth of published resources initially proved frustrating, my sense of discovery—as I pored over forgotten artworks, letters, diaries, and memoirs—was all the more exhilarating. I was not alone in this experience: feminists and scholars across the country were looking for history in humble places, and multiculturalism was about to expand the notion of American Heritage to embrace whole cultures it had previously shut out.

Much of the work in *Anonymous Was a Woman* was created more than a century ago, and throughout the intervening decades traditional women artists and writers only grudgingly won recognition. In the fifteen years since the book's publication, however, respect for ordinary Americans' contributions to our arts and letters has accelerated a hundredfold. Today, folk art of every era and ethnicity thrives in the marketplace; "domestic arts" have graduated into a hip, even subversive course of study on college campuses; and the quilt has been reborn as a vibrant, provocative collectible that attracts buyers of traditional and contemporary art alike.

Reflecting on how much we've learned since *Anonymous Was a Woman* first appeared, I feel that its insights endure because the experiences it draws on are timeless. Artworks here celebrate, commemorate or communicate what words alone cannot convey—the joy of a birth; the heartbreak of an untimely death; the anguish of parting from a loved one. Women poured these feelings into quilts, woven rugs, or embroidered linens that would bring the giver to mind with every use. Similarly, the guileless confidences committed to women's letters and diaries spring from the page with a candor that defies the passage of time.

Now as then *Anonymous Was a Woman* reminds us that women's art arises from daily life. Indeed, samplers, paintings, quilts, and needlework gain in force and dignity when understood as the creative expressions of everyday people whose main concerns were raising children, running farms or homes, and enriching the world with their "useful work."

Coaxing women folk artists out of anonymity was not merely a matter of dis-

covering names or assigning dates. The real task was to conjure up the public and private spheres of girls and women who executed the most intricate quilt patterns without ever mastering the formal principles of geometry, who evoked the most exotic imagery in thread or paint without ever traveling beyond their counties of birth.

Unfortunately, the artists themselves rarely left accounts of their work. In most cases they would not have dreamed of presenting themselves as "artists," or their samplers, school pieces, and needlework as "art." And so, where direct testimony was lacking I drew on period documents—"domestic receipt" books, sermons, etiquette pamphlets, and ladies' magazines—for the representations of "true womanhood" that codified appropriate feminine taste and conduct. From diaries, letters, and memoirs of generations of girls and women I selected passages that illuminate the intense aspirations contained in their "utilitarian" creations. Stories, poems, songs—even fragmentary jottings of families and loved ones—contributed detail to the composite life story of the Anonymous Woman, who ornamented every phase of her experience from girlhood through old age with handiwork of startling power and invention.

Beauty soon grows accustomed to the eye
Virtue alone has charms that never die.
Old sampler verse

In the beginning was the Sampler. Girls as young as five or six stitched alphabet, numerals, and simple rhyme into homely little masterworks that laid down the law for a virtuous life: literacy, piety, and needle wisdom. Indeed through years of growing skill in every kind of handiwork, the needle would be a woman's most constant companion.

At female academies, where scholarship slowly gained ground as the nineteenth century wore on, domestic arts and "elegant accomplishment" initially dominated the curriculum. Imitation, it was believed, produced mastery. Students painstakingly translated still lifes, florals, pastorals, and memorial scenes into needle pictures, and produced "theorem paintings" by applying pigment through stencils onto paper, velvet, or wood. As classroom artists moved on to more ambitious compositions they ransacked English and French engravings for every detail of landscape, architecture, and pose. Fresh-faced and domesticated, these motifs reemerged in romantic pastorals and sober mourning pictures all over the nation.

Once educated, the American girl was expected to marry, and the conscientious wife found ways to beautify her home by calling on skills developed in girlhood. Habits of usefulness so rigorously instilled shaped even her odd moments of leisure. Whether in company or alone, a woman rarely left her needle at rest. As she dipped into her scrap bag, it found its most sophisticated expression in quilting.

The quilt, that most anonymous of feminine creations, rarely dated or signed, summarized in bits of colored cloth the major themes of a woman's life. In bridal quilts, patchwork baby coverlets, "album" quilts made collectively to honor relatives, friends, or local notables—even in widow's quilts—a woman said everything she knew about art and survival.

Having irretrievably lost the way of life that produced early American folk art, we have come to value its spirit all the more. It demonstrates patience, attention to the humblest detail, sensitivity to the beauty of everyday life, and—perhaps most poignantly for us—faith in the future. Overwhelmingly these works were made to be used, cherished, and passed on to future generations. For their makers they were acts of love and duty performed in their appropriate season. For us they are clear-eyed, beguiling artifacts, full of "charms that never die."

What follows is not a scholarly documentation of our folk legacy but an illumination of the lives of the people who created it. It is a celebration in words and images of the Anonymous Woman's will to clarify and beautify the ordinary world.

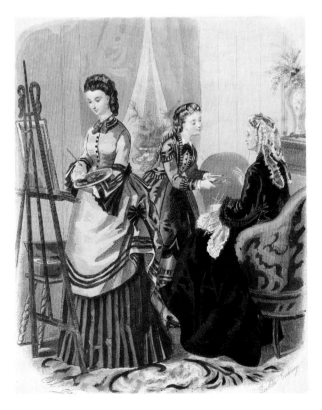

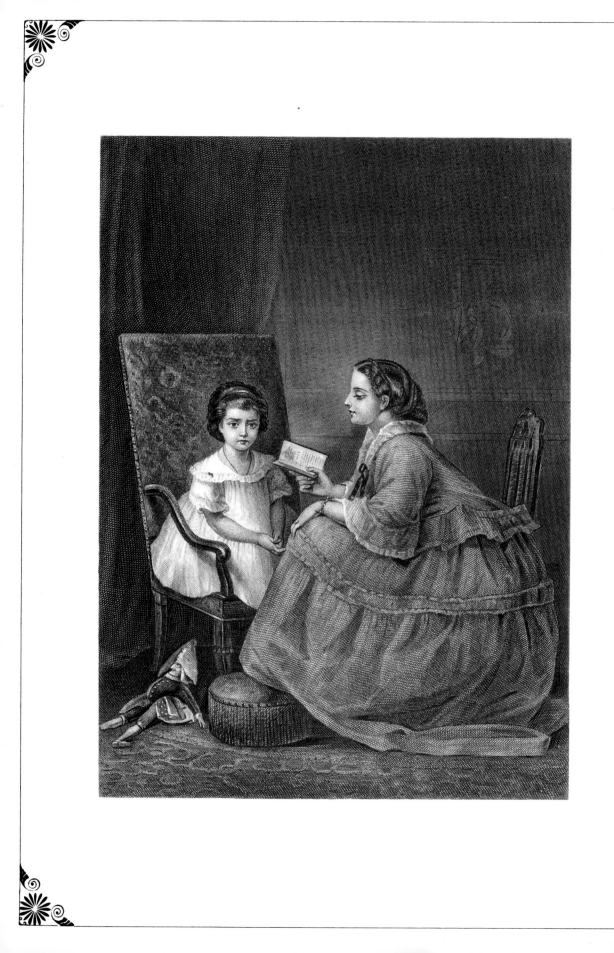

Lessons in
Womanhood

Young ladies should be taught that usefulness is happiness, and that all other things are but incidental.

Lydia Maria Child, *The American Frugal Housewife,* 1832

In the older times it was seldom said to little girls, as it always has been said to boys, that they ought to have some definite plan, while they were children, what to be and do when they were grown up. There was usually but one path open before them, to become good wives and housekeepers. And the ambition of most girls was to follow their mothers' footsteps in this direction; a natural and laudable ambition. But girls, as well as boys, must often have been conscious of their own peculiar capabilities—must have desired to cultivate and make use of their individual powers.

Lucy Larcom, *A New England Girlhood,* 1889

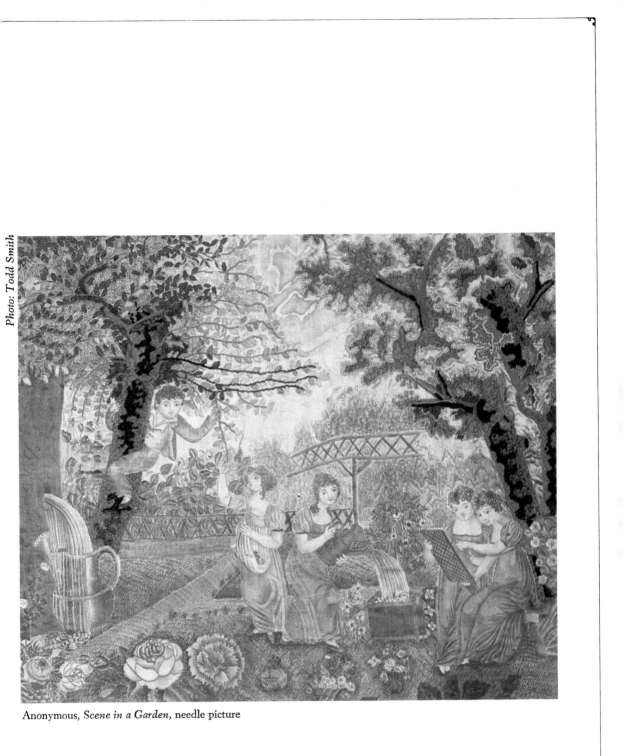

Anonymous, *Scene in a Garden,* needle picture

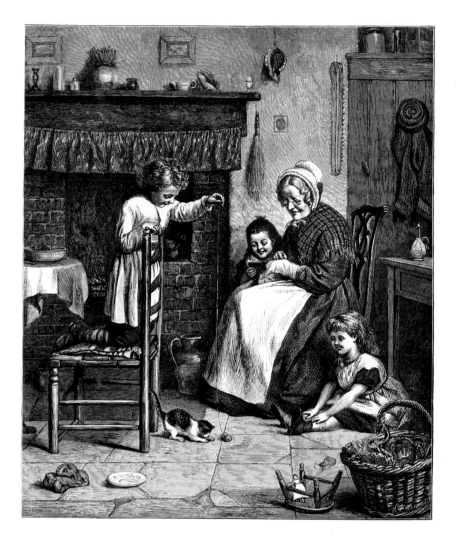

Aunt Hannah used her kitchen or her sitting-room for a schoolroom. . . .

One of our greatest school pleasures was to watch Aunt Hannah spinning on her flax-wheel, wetting her thumb and forefinger at her lips to twist the thread, keeping time, meanwhile, to some quaint old tune with her foot upon the treadle. . . .

. . . I learned my letters in a few days, standing at Aunt Hannah's knee while she pointed them out in the spelling book with a pin, skipping over the "a b abs" into words of one and two syllables, thence taking a flying leap into the New Testament.

Lucy Larcom, *A New England Girlhood*, 1889

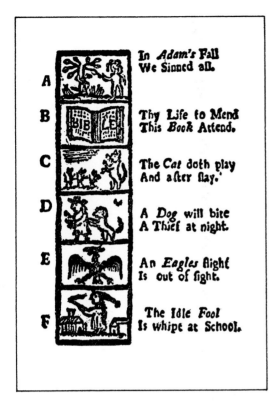

. . . with what genuine delight I would con—

> *In Adam's fall*
> *We sinned all.*
> *The cat doth play,*
> *And after slay.*

With what pride I would repeat: "Who was the first man? Adam; Who was the first woman? Eve; Who was the first murderer? Cain; Who was the first martyr? Abel," and the long list of Biblical biography.

Sarah Anna Emery
Reminiscences of a Nonagenarian, 1879

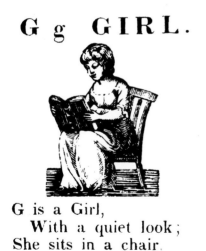

G is a Girl,
 With a quiet look;
She sits in a chair,
 And reads in a book.

August 6, 1849. *I think spelling is very funny, I spelt infancy infantsy, and they said it was wrong, but I don't see why, because if my seven little cousins died when they were infants, they must have died in their infantsy; but infancy makes it seem as if they hadn't really died, but we just made believe.*

Diary of Catherine Elizabeth Havens, age 11

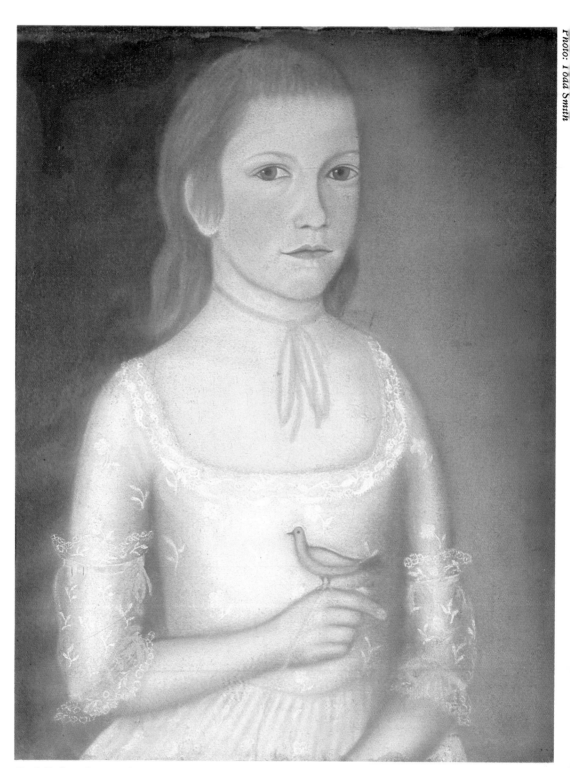

Sarah Perkins, *Lucy Perkins,* pastel

1845

A Sample of Our Lessons:

"What virtues do you wish you had more of?" asks Mr. L.
I answer:

Patience,	*Love,*	*Silence,*
Obedience,	*Generosity,*	*Perseverance,*
Industry,	*Respect,*	*Self-denial.*

"What vices less of?"

Idleness,	*Wilfulness,*	*Vanity,*
Impatience,	*Impudence,*	*Pride,*
Selfishness,	*Activity,*	*Love of cats.*

Louisa May Alcott, age 12

. . . he would not permit his female pupils to cipher in "Fractions."

It was a waste of time, wholly unnecessary, would never be of the least use to them. If we could count our beaux and our skeins of yarn it was sufficient.

Sarah Anna Emery
Reminiscences of a Nonagenarian, 1879

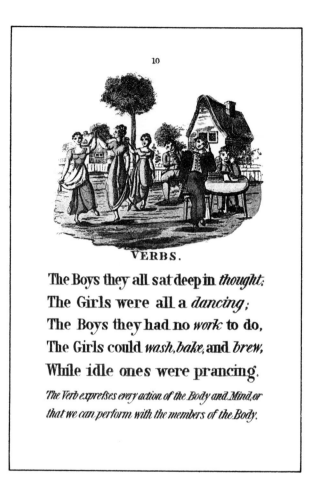

10

VERBS.

The Boys they all sat deep in *thought;*
The Girls were all a *dancing;*
The Boys they had no *work* to do,
The Girls could *wash, bake,* and *brew,*
While idle ones were prancing.

*The Verb exprefses every action of the Body and Mind, or
that we can perform with the members of the Body.*

. . . *We learned to sew patchwork at school, while we were learning the
alphabet; and almost every girl, large or small, had a bed-quilt of her own begun,
with an eye to future house furnishing. I was not over fond of sewing, but I
thought it best to begin mine early.*

*So I collected a few squares of calico, and undertook to put them together
in my usual independent way, without asking direction. I liked assorting those
little figured bits of cotton cloth, for they were scraps of gowns I had seen worn,
and they reminded me of the persons who wore them.*

Lucy Larcom, *A New England Girlhood,* 1889

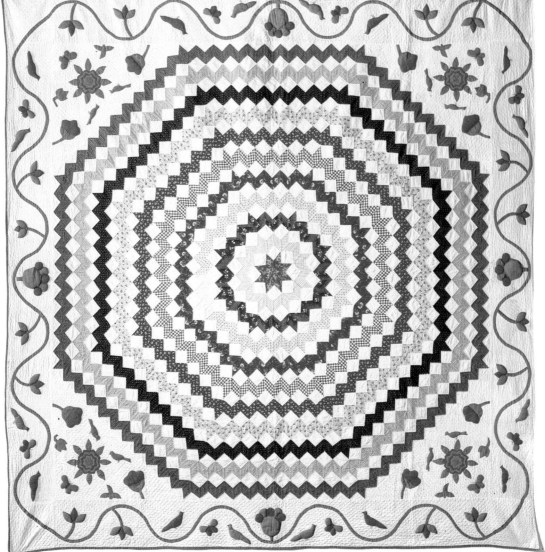

Louisa Williams, age 14, *Pieced and Appliqué Quilt*

A little girl may begin, at five or six years of age, to assist her mother; and if properly trained, by the time she is ten, she can render essential aid. From this time until she is fourteen or fifteen, it should be the principal object of her education to secure a strong and healthy constitution, and a thorough practical knowledge of all kinds of domestic employments.

Catherine E. Beecher, *A Treatise on Domestic Economy*, 1843

"Clarissa," said my judicious mother, "by not knowing how to make puddings and pies, you may be occasionally mortified; but if you are ignorant of roasting and boiling, you may be annoyed every day."

Clarissa Packard,
Recollections of a Housekeeper, 1834

1791

April 1. *I wove two yards and three quarters and three inches to-day and I think I did pretty well considering it was April Fool Day.*

Aug. 16. *I picked blue wool.*

Aug. 17. *I broke blue Wool.*

Aug. 19. *I carded blue Wool. Ma spun.*

Diary of Elizabeth Fuller, 1791–92

I think it must have been at home, while I was a small child, that I got the idea the chief end of woman was to make clothing for mankind. . . .

This thought came over me with a sudden dread one Sabbath morning when I was a toddling thing, led along by my sister, behind my father and mother. As they walked arm in arm before me, I lifted my eyes from my father's heels to his head, and mused: "How tall he is! And how long his coat looks! and how many thousand, thousand stitches there must be in his coat and pantaloons! And I suppose I have got to grow up and have a husband, and put all those little stitches into his coats and pantaloons. Oh, I never, never can do it!"

A shiver of utter discouragement went through me. With that task before me, it hardly seemed to me as if life were worth living. I went to meeting, and I suppose I forgot my trouble in a hymn.

Lucy Larcom, *A New England Girlhood*, 1889

Every young girl should be taught to do the following kinds of stitch, with propriety. Overstitch, hemming, running, felling, stitching, back-stitch and run, button-stitch, chain-stitch, whipping, darning, gathering and cross-stitch.

When a person is troubled with damp fingers, a lump of soft chalk, in a paper, is useful to rub on the ends of the fingers.

Catherine E. Beecher, *A Treatise on Domestic Economy,* 1843

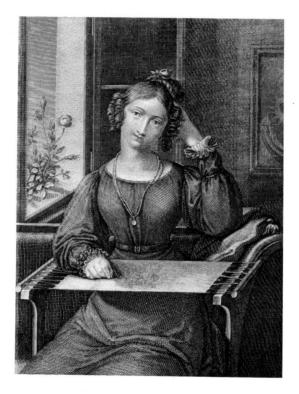

The Prayse of the Needle

To all dispersed sorts of Arts and Trades
I write the Needles prayse (that never fades)
So long as children shall begot and borne,
So long as garments shall be made and worne.
So long as Hemp or Flax or Sheep shall bear
Their linnen Wollen fleeces yeare by yeare;
So long as silkworms, with exhausted spoile,
Of their own entrailes for man's gaine shall toyle;
Yea, till the world be quite dissolved and past,
So long at least, the Needles use shall last.

John Taylor, 1580–1653

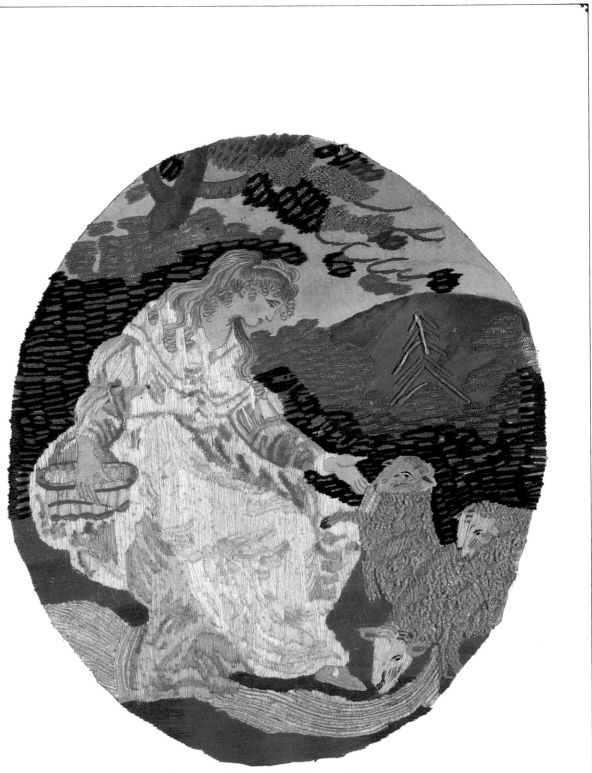

Anonymous, *Woman With Sheep,* needle picture

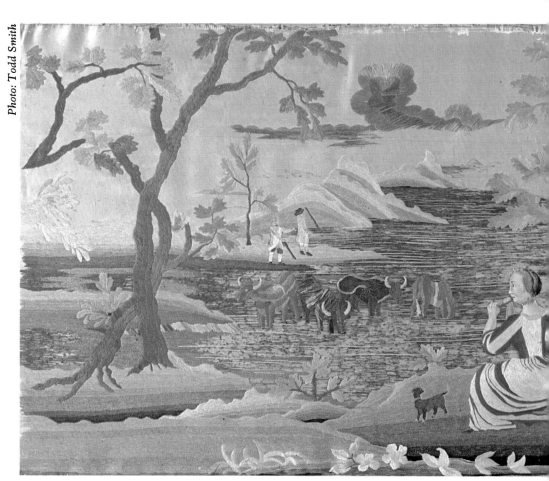

Mary Trumbull, needle picture

Needle-work, in all its forms of use, elegance and ornament, has ever been the appropriate occupation of woman. From the shades of Eden, when its humble process was but to unite the figleaf . . . down to modern times, when Nature's pencil is rivalled by the most exquisite tissues of embroidery, it has been both their duty and their resource.

<div align="right">Lydia H. Sigourney, Letters to Young Ladies, 1837</div>

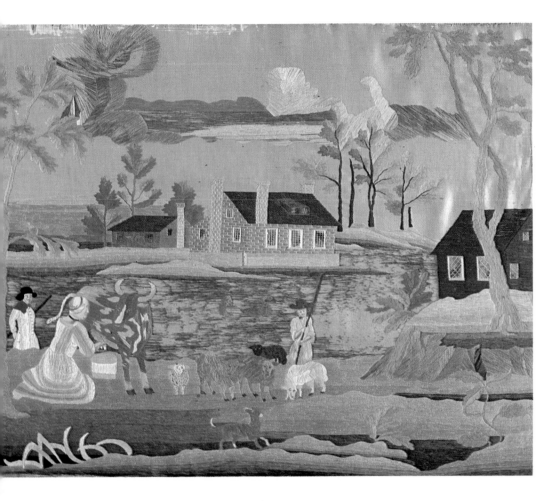

Whatever endears home, or renders it agreeable,
is worthy of female attention and study.

A Mother, *Thoughts on Domestic Education,
the Result of Experience,* 1829

One was considered very poorly educated who could not exhibit a sampler; some of these were large and elaborate specimens of handiwork; framed and glazed, they often formed the chief ornament of the sitting room or best chamber.

Sarah Anna Emery, *Reminiscences of a Nonagenarian*, 1879

When I was young & in my Prime
You see how well I spent my time.
And by my sampler you may see
What care my parents took of me.

Traditional sampler verse

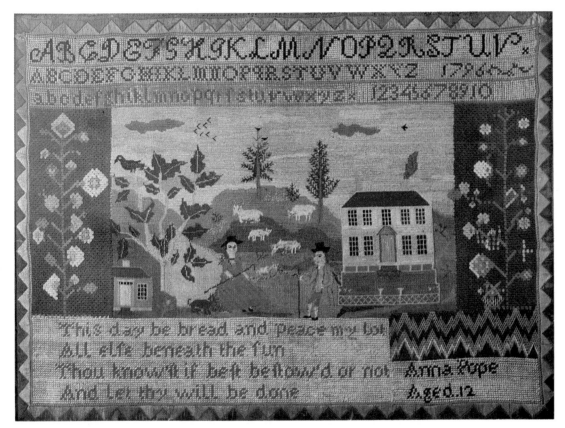

Anna Pope, *Sampler*

. . . *she began with the alphabet and numerals, following them with a Scriptural text or verse of a metrical psalm. Then fancy was let loose on birds, beasts, and trees.*

Alice Morse Earle, *Colonial Days in Old New York*, 1890

SAMPLER WISDOM

1736

Labor for learning before you grow old
for it is better than silver or gold
When silver is gone and money is spent
then learning is most excellent.

1802

Of female arts in usefulness
The needle far excels the rest
In ornaments there's no device
Affords adornings half so nice.

1815

Friendship's a name to few confin'd,
The offspring of a noble mind.
A generous warmth which fills the breast,
And better felt than e'er exprest.

1817

With cheerful mind we yield to men
The higher honors of the pen
The needle's our great care
In this we chiefly wish to shine
How far the arts already mine
This sampler does declare.

1833

Then let thy heart
Who ere thou art
To wisdom's way incline
Use well this hour
While in thy power
For the next may not be thine.

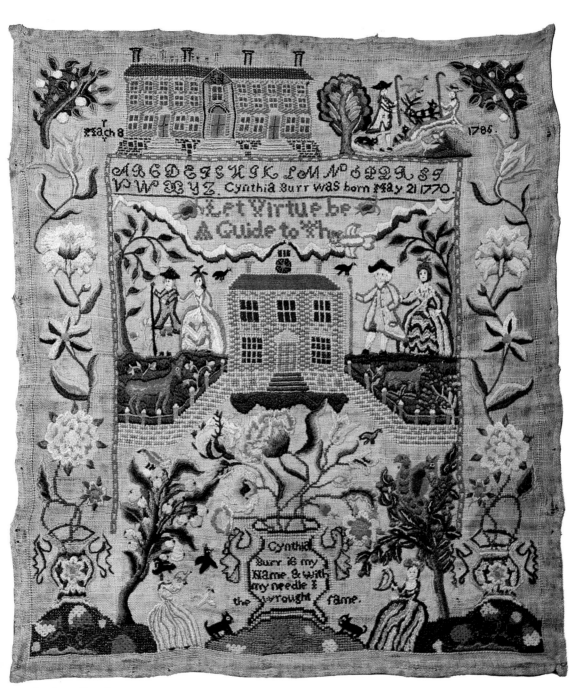

Cynthia Burr, *Sampler*

Mary Batchelder, *Sampler*

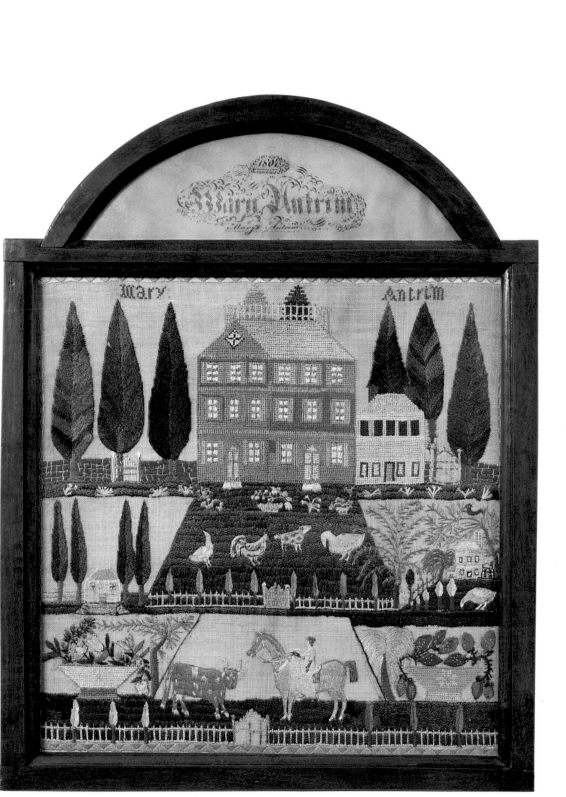

Mary Antrim, *Sampler*

My sampler was one of unrivalled beauty. It possessed every shade and glory of tent-stitch. At the upper corners were cherubs' heads and wings. Under the alphabet stood Adam and Eve, draperied with fig-leaves.

Clarissa Packard, *Recollections of a Housekeeper*, 1834

Adam alone in Paradise did grieve,
And thought Eden a desert without Eve,
Until God pitying of his lonesome state
Crowned all his wishes with a loving mate.
What reason then hath man to slight or flout her,
That could not live in Paradise without her?

From the sampler of Mary Gates, 1796

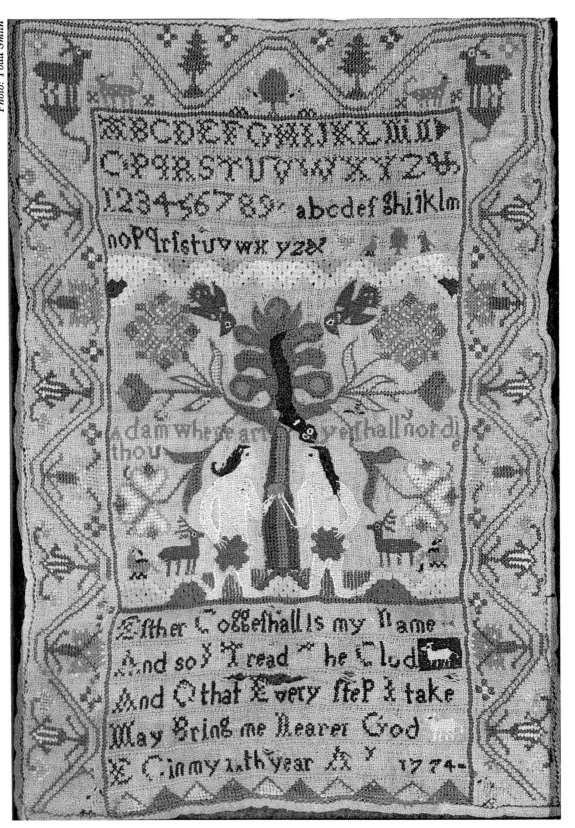

Esther Coggeshall, *Sampler*

Mrs. Hurley, late from London, respectfully acquaints the inhabitants of Cambridge, and its Vicinity, that she has Opened a School for the Instruction of Young Ladies; next door to the Church, on the Green, near the University.

She will instruct in Reading, Writing, & Arithmetic, Grammar, Geography, & History, with Rudiments of the French Language.

All kinds of Needlework, Tambour, Embroidery, & Drawing, upon very moderate Terms.

She presumes, that by an unremitting diligence, she shall merit the favor of all those who honour her with the care of their children.

The terms are from Three to Six Dollars per quarter.

All kinds of Needlework and Millinery shall be done, in the newest taste, with elegance and dispatch.

Independent Chronicle and Universal Advertiser, Boston, October 17, 1799

QUESTIONS

Have you rose early enough for the duties of the morning. Have you read a portion of scripture by yourself. Have you prayed to that God in Whose hands your breath is. . . .

Have you been neat in your person, made no unnecessary trouble by carelessness in your chamber or with your clothes. Have you torn your clothes, books, or maps. Have you wasted paper, quills, or any other articles. Have you walked out without liberty. Have you combed your hair with a fine tooth comb, and cleaned your teeth every morning. Have you eaten any green fruit during the week.

> Copied by Eliza Ann Mulford, 1814, "Rules for the School and Family"
> Miss Pierce's School, Litchfield, Connecticut

Thursday attended school in the Morning—recited a lesson in Grammar and painted. In the evening went to Conference. Saturday Morning, wrote journal, in the afternoon quilted for Miss Anne Baldwin. After tea took a short walk, in the evening, sung psalms and heard prayers.

Monday Morning Went to School—read history, painted in the Afternoon, the evening took a short walk with Miss McMehan and sew'd. Tuesday recited a lesson in geography, the afternoon Copied notes with My dear friend Miss Trasy.

Sunday attended Church. In the evening went to singing school with My Dear friend Miss Trasy. The more I am with that Dear Girl the stronger does my affection grow. . . .

Saturday Miss Pierce told the young ladies faults separately. She said it would be the last time she would ever have an opportunity of doing it. She said the only fault I had had was daubing my paintings. She closed with a very handsome prayer.

> Catherine van Schaack, "A Journal for the Summer, 1809"
> Miss Pierce's School, Litchfield, Connecticut

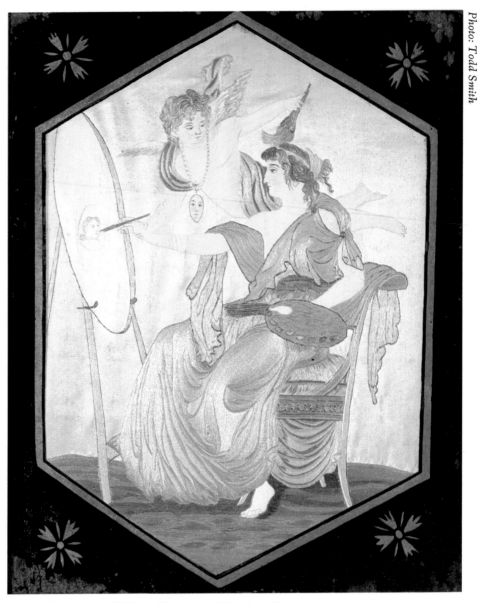

Photo: Todd Smith

Mary C. West & Lucy H. West, *The Artist & Cupid,* needle picture

. . . *when I heard that there were artists, I wished
I could some time be one.*
 *If I could only make a rose bloom on paper, I thought I should be happy!
or if I could at last succeed in drawing the outline of winter-stripped boughs
as I saw them against the sky, it seemed to me that I should be willing to spend
years in trying.*

Lucy Larcom, *A New England Girlhood,* 1889

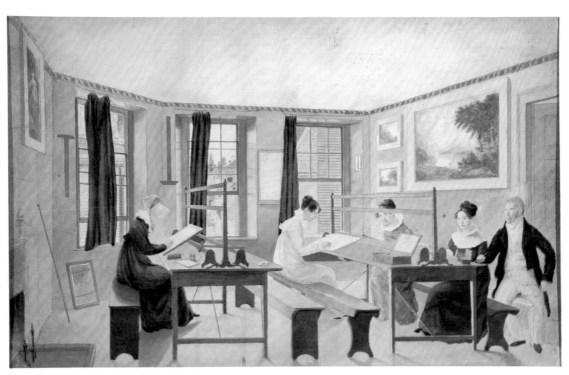

Anonymous, *The Watercolor Class,* oil on canvas

It is needful that I calm your apprehensions, your fear that your daughters will become real artists only by drawing nude figures from nature.

Have I not said, that woman should never, under any pretext, forget her womanhood; that to be a woman is her first condition in life?

She must confine herself to those subjects which are allied to her sphere. . . . her domain is large enough, and beautiful enough . . . with women, children, animals, fruits, flowers, etc.—one may create masterpieces for a lifetime.

. . . But when a woman desires to paint large-sized pictures, and mounts the ladder, she is lost—lost as a woman.

Mme. M. Elizabeth Cavé, *Drawing from Memory,* 1877

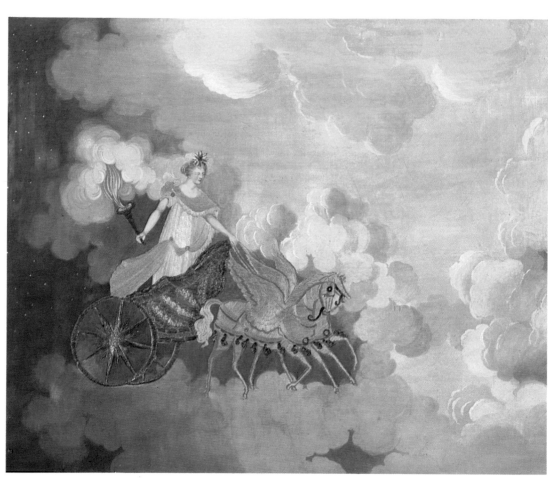

Abby Eddy, *Aurora,* needlework and paint

Children and partially nude women; these are the extreme limit for us.

Mme. M. Elizabeth Cavé, *Drawing from Memory,* 1877

Painting in water colors is the kind of painting most convenient for ladies; it can be performed with neatness, and without the disagreeable smell which attends oil painting.

Mrs. A. H. L. Phelps, *The Fireside Friend or Female Student,* 1840

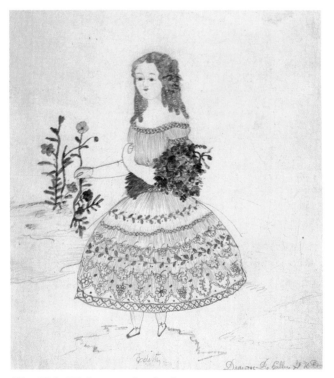

Hannah Crowninshield, *Pompey the Cat,*
watercolor

Ellen Holt, *Edith,* watercolor sketch

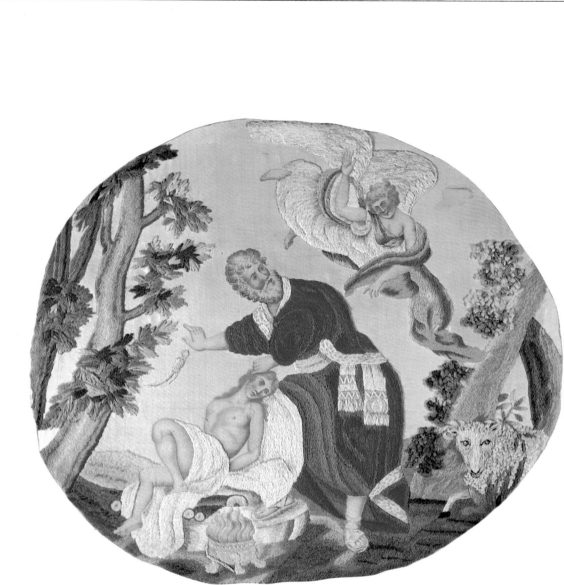

Photo: Todd Smith

Eliza Greening, *Abraham & Isaac,* needle picture

At each of the female schools, in addition to knitting and plain sewing, ornamental needlework was taught. . . .

Mourning pieces were in vogue, though some preferred scriptural or classical subjects.

Sarah Anna Emery, *Reminiscences of a Nonagenarian,* 1879

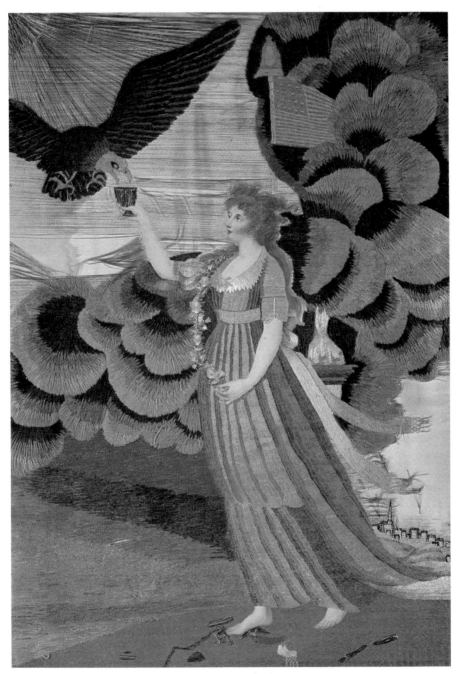

Mary Green, *Liberty,* needle picture

June 30, 1804 John Green/Worcester
I shall begin my embroidery scool tomorrow to work the piece liberty
and the 14 united states.

Mary Green, Letter to her father

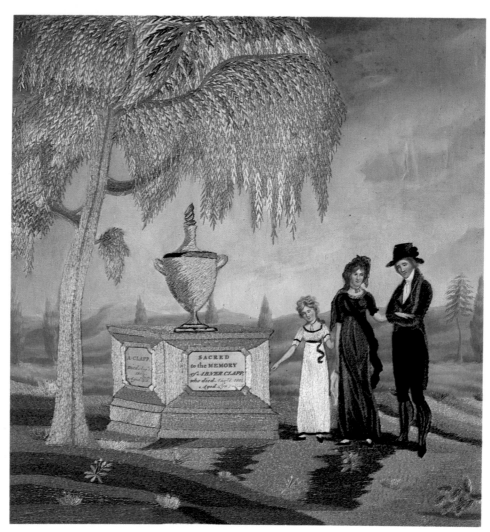

Hannah Clapp, *SACRED to the MEMORY of ABNER CLAPP* . . . , needlework and paint

Brewster (Mass.), 11th September, 1806

Dear Daughter,
We are well and hope this will meet you with the same. I wish you now to work
in embroidery a mourning piece in memory for your brother Strabo—who died
June 29, 1799 aged 8 months and 13 Days. You must wright by every post
and let me know how fast you progress in your education and at all times
remember to behave well, and conduct in Decency in all your
transactions through life. . . .

from your affectionate father,
Isaac Clark

As a child, the gulf between little girlhood and young womanhood had always looked to me very wide. I supposed we should get across it by some sudden jump, by and by. . . .

I began to reflect upon life rather seriously. . . . What was I here for? What could I make of Myself? Must I submit to be carried along with the current, and do just what everybody else did? No: I knew I should not do that, for there was a certain Myself who was always starting up with her own original plan or aspiration before me, and who was quite indifferent as to what people generally thought.

Well, I would find out what this Myself was good for, and what she should be!

Lucy Larcom, *A New England Girlhood,* 1889

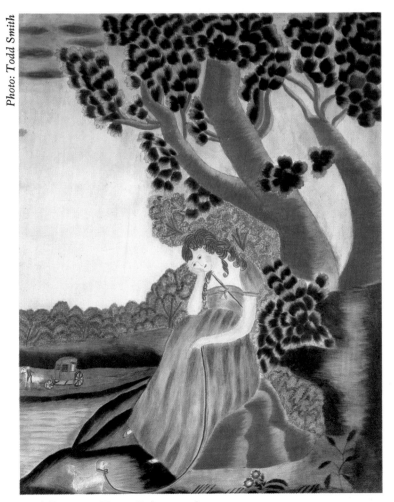

Photo: Todd Smith

Sarah Lawrence, *Young Girl,* watercolor

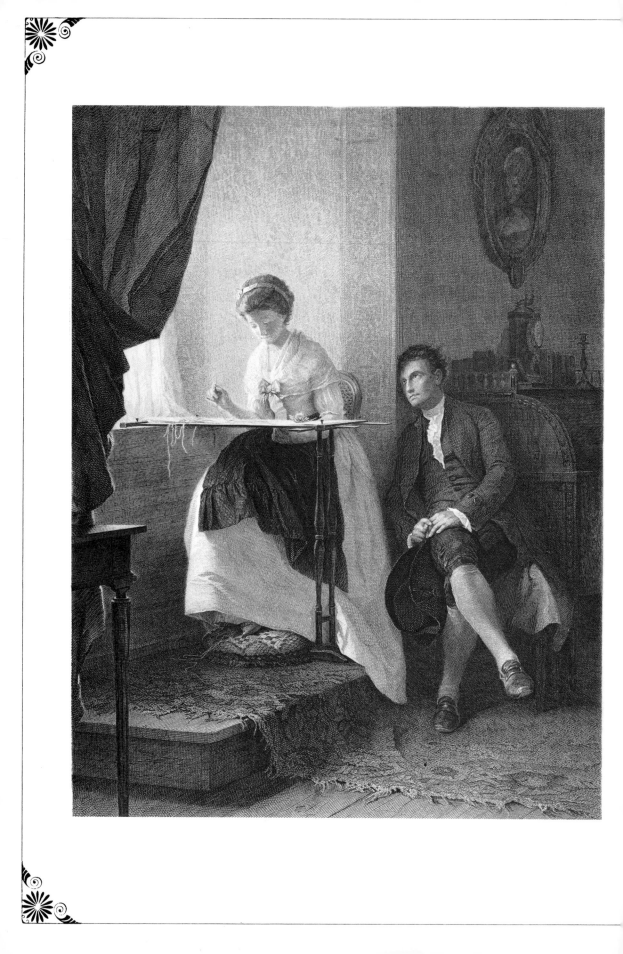

Will You Be Married?

We are as truly bound to marry . . . as we are to eat, drink, sleep, labor or pray.

William A. Alcott, *Moral Philosophy of Courtship & Marriage*, 1857

April 15, 1850. *When I grow up I think I shall have a beau, and his name is Sam B. and he lives across the street, for he sent me a valentine he painted himself, and it is a big red heart with an arrow stuck through it, and one of my school friends says that means he is very fond of me, but I don't see much sense in the arrow.*

Diary of Catherine Elizabeth Havens, age 13

Sept. 17, 1782. . . . *Lucy Gordon is truly a good Girl, but nothing of the romance in her. So much the better, say I, she is much happier without. I wish to Heaven I had as little.*

Journal of Lucinda Lee Orr

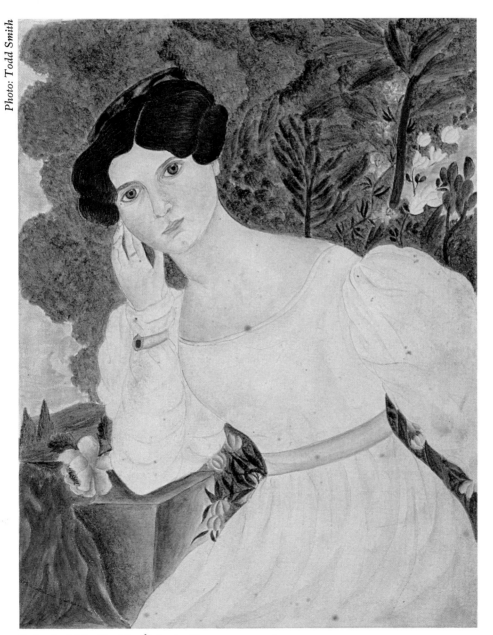

Deborah Goldsmith, *Miss Catherine N* . . . , watercolor

May 23, 1814. *To be sure—I shall choose a wife, but it must be a matter of calculation and regularly composed like an Apothecary's bill—ten grains of neatness, two of industry and two of amiability, a teacup full of "brains"— acquired knowledge, talents to be immersed in a silver cup—with a handful of flowers of beauty flung in.*

Journal of John P. Brace

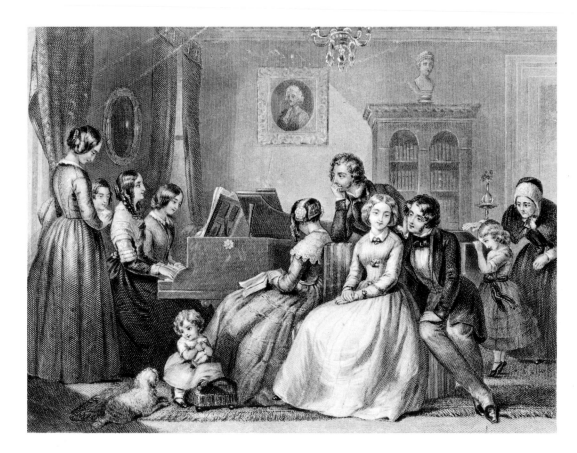

July 28, 1820. *Never could I give my hand unaccompanied by my heart. No, Laura, there must first be an individual whose face my being feels redoubled life in seeing 'ere I can resign my present freedom. . . . I have witnessed the unhappiness that exists where minds are "fettered to different molds"—and rather than be subject to the "eternal strife" which in such cases prevails, I would ever remain in "single blessedness" and deem it felicity thus to live.*

Eliza Chaplin, Letter to Laura Lovell

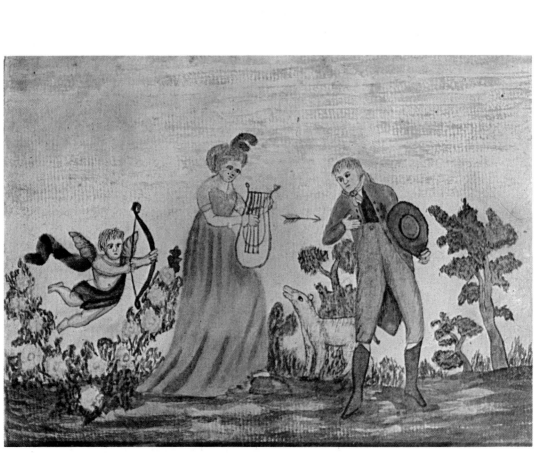

Eunice Pinney, *Cupid's Arrow*, watercolor

May 12, 1802. *Strange that celibacy should be the crying sin of the age. . . .*
There are more blanks than prizes in the matrimonial lottery.

Diary of Mary Orne Tucker

Dear Father and Mother

 . . . I can never be happy there in among so many mountains . . . and as for marrying and settling in that wilderness, I won't. If a person ever expects to take comfort it is while they are young. I feel so.

 What can we get off that rocky farm only 2 or 3 cows. . . . It surely would be cheaper for you to hire a girl, one that would be contented to stay in the desert than for me to come home and live in trouble all the time. . . . I have but one life to live and I want to enjoy myself as well as I can while I live. . . . My love to all who inquire after.

Sally Rice, age 17, Vermont, 1845

At four o'clock attended Academy Hall (at Colonel Denny's Hall) with A. Perry. Cousin William Bass of Boston in company with us. Upwards of one hundred and twenty ladies and gents made their appearance and danced until past twelve and then retired; probably

> *Some pleased and some disgusted,*
> *Some with rigging maladjusted,*
> *Some merry, some sad,*
> *Some sorry, some glad,*
> *Some elated, others tired,*
> *Some neglected, others admired,*
> *Some jovial, some pouting,*
> *Some silent, some shouting,*
> *Some are calm, some are crazy,*
> *Some sprightly, some lazy,*
> *Some resolved to keep awake,*
> *Some resolved their sleep to take.*
> *I am of the lazy crew,*
> *Sense and nonsense,*
> *Both adieu!*

Diary of Ruth Henshaw Bascom, ca. 1800

Quilting at Mr. Andrew's. Had a great number of gallants. "Wool break"
at Mr. Southgate's, spinning frolic at Mr. Green's. Had a Cappadocian Dance.
Mr. Shaw played for us.

Diary of Ruth Henshaw Bascom, ca. 1800

When I Saw Sweet Nellie Home

In the sky the bright stars glittered,
On the grass the moonlight shone;
From Aunt Dinah's quilting party,
I was seeing Nellie home.

When the autumn tinged the greenwood,
Turning all its leaves to gold,
In the lawn by the elders shaded,
I my love to Nellie told;
As we stood together, gazing
On the star-bespangled dome,
How I blessed the August evening,
When I saw sweet Nellie home.

Traditional Song, first published 1858

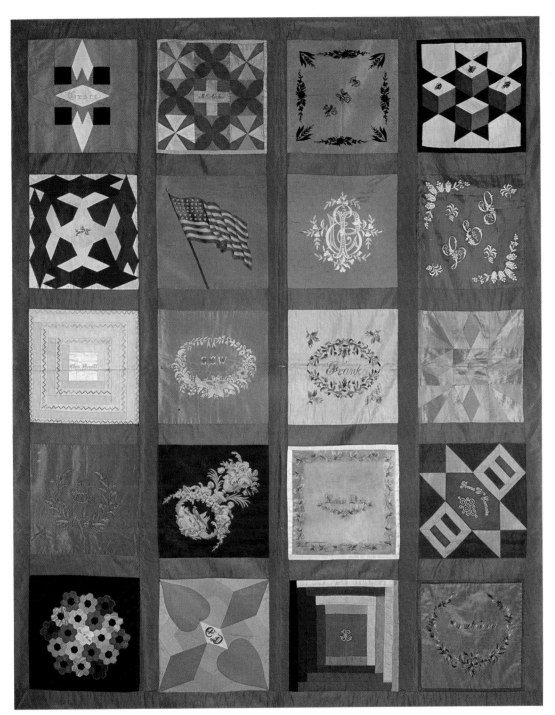

Pieced by Ella L. Platt, *Engagement Quilt*

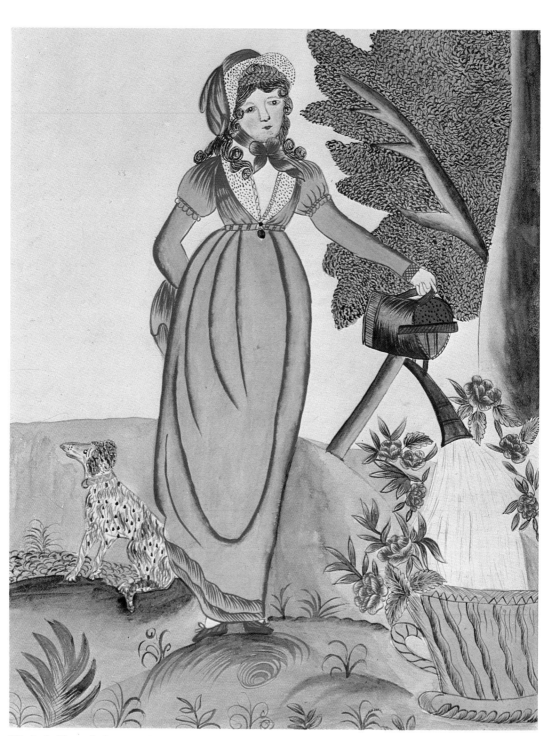

Elizabeth Glaser, *Lady in a Yellow Dress Watering Roses*, watercolor

June 22, 1872. *Wonder if I shan't be the biggest fool that ever was if I ever get married—haven't I done everything this week that was ever thought of? I've found or taken time to play croquet once—my polonaise is done—my picture is done and I've done lots of housework, washed five floors today, fried donuts before breakfast.*

November 3, 1872. *Well—I'm almost 22. I feel old myself but it seems as if I am "very young" and very—shall I say it?—green to other people.*

Diary of A. M. Libby

February, 1854. *Tuesday—A gentleman visited our school today. When he came in, Miss Clark said, Young ladies, and we all stood up and bowed and said in concert, his name.*

We girls think he is a very particular friend of Miss Clark. He is very nice looking, but we don't know where he lives. Laura Chapin says he is an architect. I looked it up in the dictionary and it says one who plans or designs. I hope he don't plan to get married to Miss Clark and take her away and break up the school, but I presume he does, because that is usually the way.

Diary of Caroline Cowles Richards

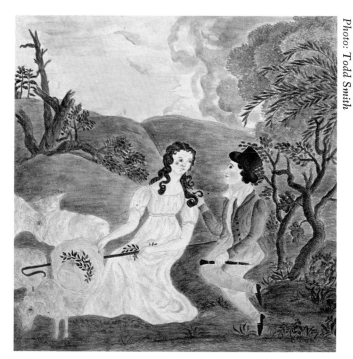

Deborah Goldsmith, *The Silesian Girl*, watercolor

Hamilton, May 20th, 1832
At Home

Miss Deborah Goldsmith
Toddsville, New York

Deborah:

. . . will it surprise thee when I declare that in thee my desires center, and all my hopes of earth happiness have an end? After mature consideration and closely examining my own heart, I find that thy friendship and thy presence will ever be delightful. . . . I claim no perfection: such as I am, I offer myself. . . . Perhaps you may think I am asking too much, but please to inform me if I am on right ground, or not. So I add no more. Adieu.

P.S. friends in health. Write soon as convenient.

Yours Sincerely,
George A. Throop

Toddsville, May 29, 1832

Mr. George A. Throop
East Hamilton, New York

Sir:
With deep interest I perused your letter, but I hardly know how to answer it. My mind is agitated with conflicting emotions, and I feel quite inadequate to the task which I have seated myself to perform. But I will tell this much, that truth and truth alone shall flow from my pen, and I sincerely hope that falsehood and deception may be far from my heart.

I do not know how long I shall stay in this place. . . . I have business enough for the present. . . . I think I shall stay here as long as I can get portrait painting.

Some things I want to remind you of, that you may weigh them well. . . . Your religious sentiments and mine are different. Do you think that this difference will ever be the cause of unpleasant feeling? Your age and mine differ. I do not know your age exactly, but I believe that I am nearly two years older than you . . . has this ever been an objection in your mind? And another thing which I expect you already know is, that my teeth are partly artificial. Nature gave me as many teeth as She usually gives her children, but not as durable ones as some are blessed with. Some people think it is wrong to have anything artificial, but I will let that subject go.

Respectfully yours,
Deborah Goldsmith

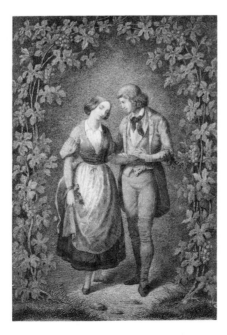

Feb. 1, 1824

Dear Julia,

I would go ever so far on foot to see you, tonight. I feel sad when I don't see you. Be married, why won't you? And come to live with me. I will make you as happy as I can. You shall not be obliged to work hard; and when you are tired you may lie in my lap, and I will sing you to rest with "There's Nothing True but Heaven." I will play you a tune upon the violin as often as you ask and as well as I can, and leave off smoking, if you say so. I would be always very kind to you, I think, because I love you so well. I will not make you bring in wood and water, or feed the pig, or milk the cow, or go to the neighbors to borrow milk. Will you be married? Little time is allotted to us in this world. Let us make the most of it while it hold out.

Aug. 2, 1824

Dear Julia,

The appointed time for the union of our destinies is near at hand. Don't look for consummate happiness—don't look for perfection in a husband.

Journal of Zadoc Long

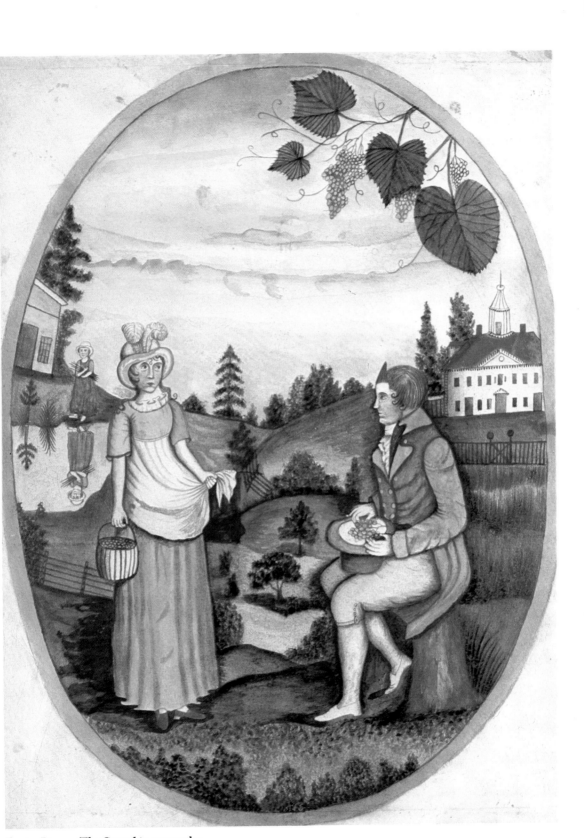

Eunice Pinney, *The Courtship*, watercolor

THE QUILTING

The quilting was in those days considered as the most solemn and important recognition of a betrothal.

When a wedding was forthcoming, then there was a solemn review of the stores of beauty and utility thus provided, and the patchwork-spread best worthy of such distinction was chosen for the quilting.

Thereto, duly summoned, trooped all intimate female friends of the bride, and the quilt being spread on a frame, and wadded with cotton, each vied with the other in the delicacy of the quilting they could put upon it; for quilting was also a fine art, and had its delicacies and nice points, concerning which grave, elderly matrons discussed with judicious care.

By two o'clock a goodly company began to assemble. Mrs. Deacon Twitchell arrived, soft, pillowy, and plaintive as ever, accompanied by Cerinthy Ann, a comely damsel, tall and trim, with a bright black eye and a most vigorous and determined style of movement.

The quilt-pattern was gloriously drawn—and soon all the company, young and old, were passing busy fingers over it, and conversation went on briskly.

Cerinthy Ann contrived to produce an agreeable electric shock by declaring that for her part she never could see into it, how any girl could marry a minister; that she should as soon think of setting up housekeeping in a meeting house.

"Oh, Cerinthy Ann!" exclaimed her mother, "how can you go on so?"

"It's a fact," said the adventurous damsel; "now, other men let you have some peace, but a minister's always around your feet."

"So you think the less you see of a husband, the better?" said one of the ladies.

"Just my views," said Cerinthy Ann, giving a decided snip to her thread with her scissors. "I like the Nantucketers, that go off on four years' voyages and

leave their wives a clear field. If I ever get married, I'm going up to have one of these fellows."

"You'd better take care, Cerinthy Ann," said her mother. "They say that 'those who sing before breakfast will cry before supper.' Girls talk about getting married," she said, relapsing into a gentle didactic melancholy, "without realizing its awful responsibilities."

. . . .

Thus the day was spent in friendly gossip as they quilted and rolled and talked and laughed. . . . The husbands, brothers, and lovers had come, and the scene was redolent of gayety. . . . Groups of young men and maidens chatted together, and all the gallantries of the times were enacted. Serious matrons commented on the cake, and told each other high and particular secrets in the culinary art, which they drew from remote family archives. One might have learned in that instructive assembly how best to keep moths out of blankets; how to make fritters of Indian corn undistinguishable from oysters; how to bring up babies by hand; how to mend a cracked teapot; how to take grease from a brocade; how to reconcile absolute decrees with free will; how to make five yards of cloth answer the purpose of six; and how to put down the Democratic party. All were busy, earnest, and certain, just as a swarm of men and women, old and young, are in 1859.

Harriet Beecher Stowe, *The Minister's Wooing*, 1859

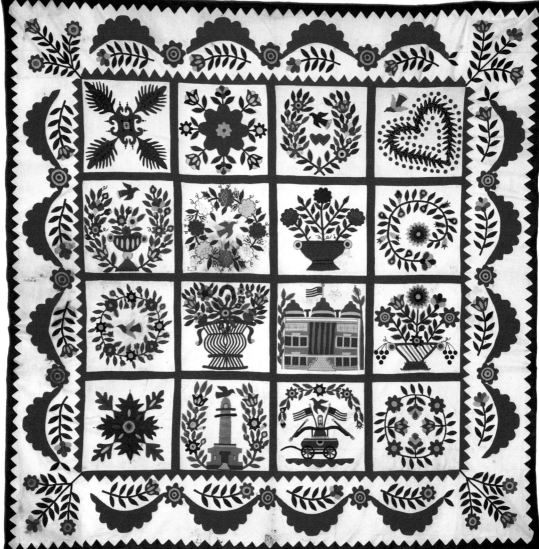

Signed Sarah A. Shafer, *Bride's Quilt*

May 29, 1832. *It does not appear to me a thing of trifling importance to think of giving myself away, and resign the protection of my parents and the home of my childhood, humble indeed, but no less dear to my heart, for other love, other protection.*

Deborah Goldsmith

December, 1837. *For your sake, my dear E. I could wish myself beautiful as houris and as graceful as Venus. But I never did, I never will reproach my Maker. When I intended to be an old maid one consolation I had was that it was nobody's business whether I was lovely or not.*

Diary of Mary Richardson Walker

Oct. 10, 1782. Mr. C. Washington returned to-day from Fredericksburg. You can't think how rejoiced Hannah was, and how dejected in his absence she always is. You may depend upon it, Polly, this said Matrimony alters us mightily. I am afraid it alienates us from everyone else. It is, I fear, the bane of Female Friendship. Let it not be with ours, my Polly, if we should ever marry. Adieu.

Journal of Lucinda Lee Orr

May, 1860. The dear girl was married on the 23rd, the same day as Mother's wedding. A lovely day; the house full of sunshine, flowers, friends, and happiness. Uncle S. J. May married them, with no fuss, but much love; and we all stood round her. She in her silver-gray silk, with lilies of the valley (John's flower) in her bosom and hair. We in gray thin stuff and roses—sackcloth, I called it, and ashes of roses; for I mourn the loss of my Nan, and am not comforted.

Journal of Louisa May Alcott

The Tow Sisters. 1854.

Maryan Smith.

Maryan Smith, *The Tow Sisters,* watercolor

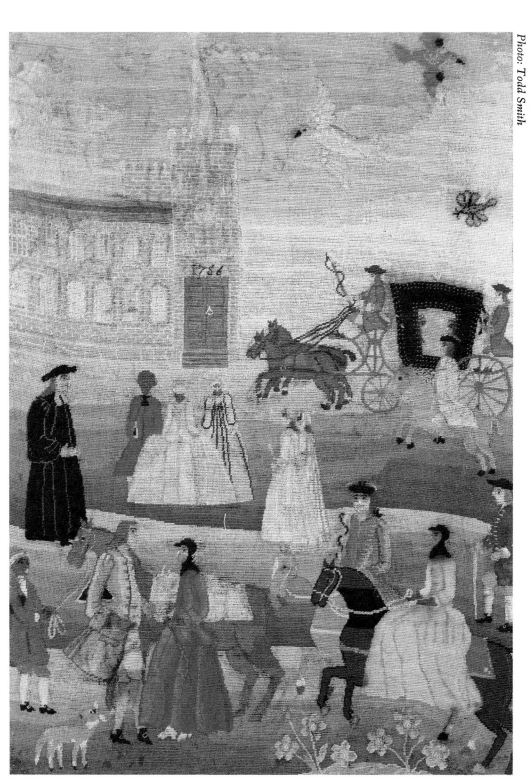

Anonymous, *The Chandler Wedding Tapestry*

To my Dear and Loving Husband

If ever two were one then surely we.
If ever man were loved by wife, then thee;
If ever wife was happy in a man,
Compare with me ye women if you can.
I prize thy love more then whole mines of gold.
Or all the riches that the East doth hold.
My love is such I can no way repay,
The heavens reward thee manifold I pray.
Then while we live, in love lets so persever,
That when we live no more, we may live ever.

Anne Bradstreet, 1632

The Wife

She rose to his requirement, dropped
The playthings of her life
To take the honorable work
Of woman and of wife.

If aught she missed in her new day
Of amplitude, or awe,
Or first prospective, or the gold
In using wore away,

It lay unmentioned, as the sea
Develops pearl and weed,
But only to himself is known
The fathoms they abide.

Emily Dickinson, ca. 1863

Nov. 10, 1812. *I gave my hand in marriage to Mr. Charles Stearns of Shelburne, and accompanied him immediately home—I have now quitted the abode of my youth, left the protection of my parents and given up the name I have always borne to enter upon a new and untried scene. . . . our intimate acquaintance has continued for more than five years . . . our constancy has been tried and affections proved and now we are calmly settled in the still, peaceful scene of domestic tranquility.*

Diary of Sarah Ripley Stearns

May 15, 1839. *You wanted I should tell you how I liked the married state. . . . I never enjoyed myself so well in my life. . . . I have not as yet had any additions to the family. . . . I made eleven hundred weight of new milk Cheese, 4 hundred of butter beside considerable skim milk cheese. We raised six calves, which was quite an addition to our stock.*

Olive Brown, Letter to Sabrina Bennett

The man bears rule over his wife's person and conduct. She bears rule over his inclinations; he governs by law; she by persuasion. . . . The empire of the woman is an empire of softness. . . . her commands are caresses, her menaces are tears.

"Matrimony," *The Lady's Amaranth II,* 1838

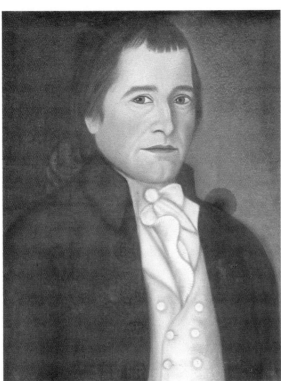

Sarah Perkins, *Dr. Caleb Perkins,* pastel

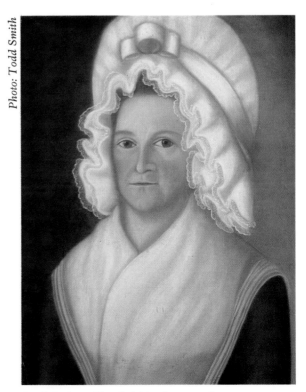

Sarah Perkins, *Mrs. Caleb Perkins,* pastel

December, 1837. *Should feel so much better if Mr. W. would only treat me with some cordiality. It is so hard to please him I almost despair of ever being able to. If I stir, it is forwardness; if I am still, it is inactivity.*

I am almost certain that more is expected of me than can be had of one woman.

January, 1838. *Last night we were disturbed by the howling of the wolves. Baked some biscuits. The first cooking I have done since I was married. Mr. Walker remarked that I had done very well. May God help me to walk discreetly and please my husband.*

Diary of Mary Richardson Walker

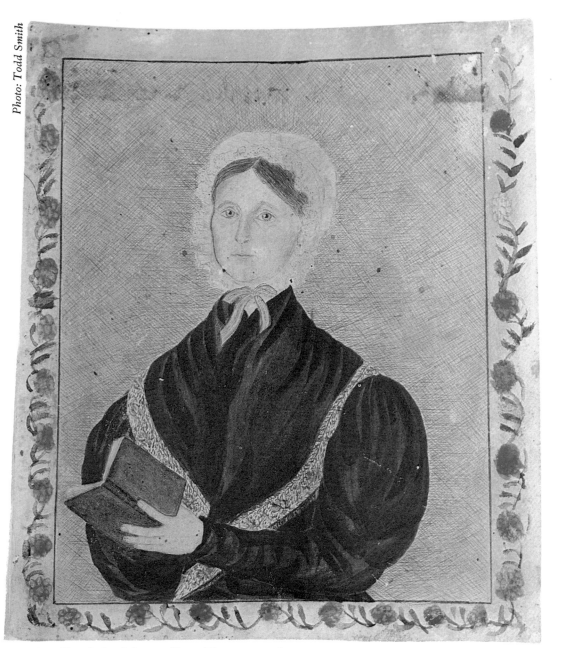

Deborah Goldsmith, *Sarah Stanton Mason Throop,* watercolor

Living a Life

No woman has a right to put a stitch of ornament on any article of dress or furniture . . . until she is sure she can secure time for all her social, intellectual, benevolent and religious duties.

Catherine E. Beecher and Harriet Beecher Stowe,
The American Woman's Home, 1869

*How much piecin' a quilt's like livin' a life. . . . The Lord sends us the pieces,
but we can cut 'em out and put 'em together pretty much to suit ourselves, and
there's a heap more in the cuttin' out and the sewin' than there is in the
caliker. The same sort o' things comes into all lives, jest as the Apostle says,
There hath no trouble taken you but is common to all men.*

Aunt Jane of Kentucky, ca. 1900

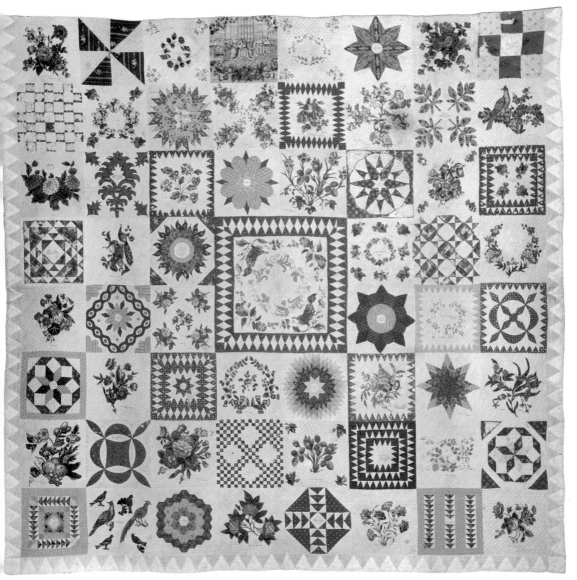

Anonymous, *Friendship "Sampler" Quilt*

Anonymous, *Baby's Quilt*

BABY BUNTING.

LULLIBY Baby Bunting,
Your Father's gone a hunting,
To catch a Rabit for a Skin,
To wrap the Baby Bunting in.

Affetuoso.

Encore 'till the Child's asleep.

BABY

April, 1838. *If I were to yield to inclination I should cry half of the time without knowing why. So much danger attends me on either hand; a long journey yet before me, going I know not whither; without mother or sister to attend me can I survive it all?*

May, 1838. *About nine I became sick enough. Began to feel discouraged, felt as if I almost wished I'd never been married. But there was no retreating. Meet it I must. About eleven I became quite discouraged as I hoped I would be delivered ere then. I was so tired and knew nothing how long before I should be relieved. But just as I supposed the worst was yet to come, my ears were saluted by the cry of my child. "A son" was the salutation. Soon I forgot my misery in the joy of possessing a proper child. In the evening my husband returned with a thankful heart and plenty of kisses for me and my boy.*

Diary of Mary Richardson Walker

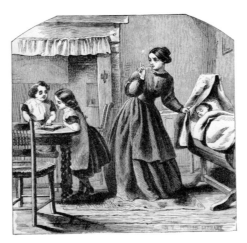

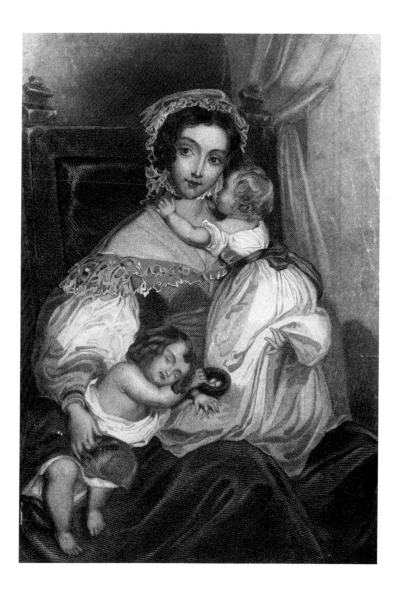

June 22, 1833. *My time is abundantly occupied with my babies. It seems to me at times as if the weight of responsibility for these little immortal beings would prove too much for me. Am I doing what is right? Am I doing enough? Am I not doing too much, is my earnest inquiry. I am almost at times discouraged if I find the result unfavorable. If I neglect everything else, I must be forgiven. I know you laugh at me and think me a slave to my children and think me foolishly anxious. I can bear it all, better than one reproach of conscience, or one thoughtless word or look given to my Anna's inquiry.*

Abigail Alcott, Letter to Lucretia and Samuel May

Eunice Pinney, *Two Women*, watercolor

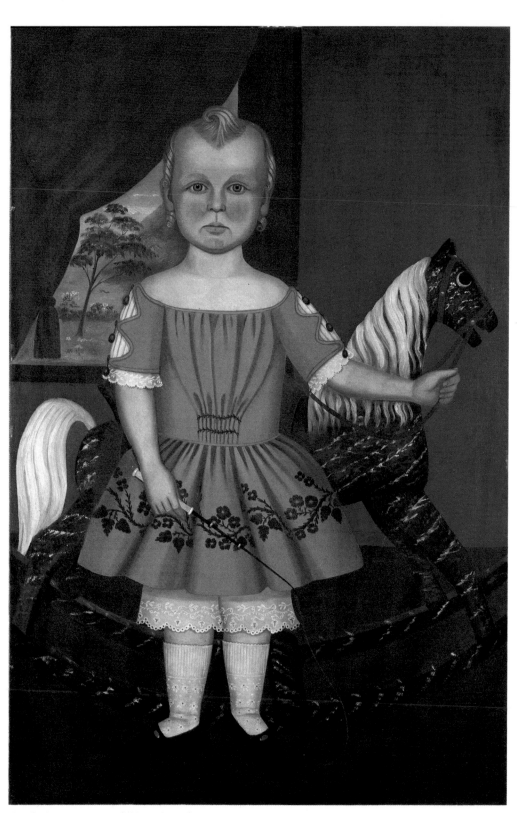

Attrib. Susan Waters, *Child With Rocking Horse,* oil on canvas

December 15, 1832. *When she plays every care is laid aside. She heeds not where she is, nor with whom. I never saw a child appear so frantic with joy. If she obtains the object of her wishes, she will skip and hop and clap her hands, and if she fall, unlike some children she don't lay it to heart, but forthwith turns her attention to new subjects.*

November 5, 1839. *Sometimes I amuse John Davis with my violin. He climbs up by holding on to the leg of my pantaloons, & stands by my knee, steadying himself with one hand while he stretches out the other to get hold of my bow. Sometimes he catches it in the middle of a tune, and makes a horrid discord. He is now sitting under a chair, & eating gingerbread with a slobbered nose.*

Journal of Zadoc Long

St. Paul knew what was best for women when he advised them to be domestic. There is something sedative in the duties which home involves. It affords security not only from the world, but from delusions and errors of every kind.

Mrs. Sandford, "Woman," *Godey's Lady's Book, II,* August, 1831

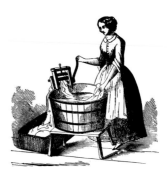

If you would avoid waste in your family, attend to the following rules, and do not despise them because they appear so unimportant: "many a little makes a mickle."

Buy your woollen yarns in quantities from some one in the country, whom you can trust. The thread stores make profits upon it, of course.

After old coats, pantaloons &c. have been cut up for boys, and are no longer capable of being connected into garments, cut them into strips, and employ the leisure moments of children, or domestics, in sewing and braiding them for door mats.

Lydia Maria Child,
The American Frugal Housewife, 1832

Keep yeast in wood or earthen.
Keep preserves and jellies in glass, or
 china or stone ware.
Keep salt in a dry place.
Keep meal in a cool dry place.
Keep ice in the cellar, wrapped in
 flannel.
Keep vinegar in wood or glass.

Sarah Josepha Hale,
The Good Housekeeper, 1839

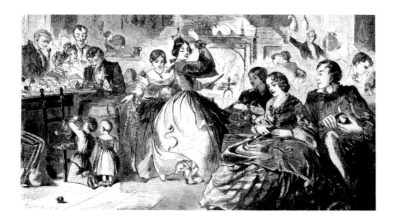

March, 1860

Mon. 5th. *Washed today. John went down to the corner to a school-meeting, I went to Julia's.*

Weds. 7th. *At home sewing on patchwork*

Thurs. 8th. *" " " " "*

Fri. 9th. *" " " " "*

Sat. 10th. *Baking and washing floors.*

Tues. 13th. *John and John Stevens went to town meeting . . . my teeth ache some.*

Weds. 14th. *John has gone again to town meeting . . . almost sick with the teeth ache.*

October, 1860

Tues. 9th. *Rather cold. Martha, Helen, Mrs. J. Marrill, Eddie, and Mr. J. Marrill were here today picking apples. I am rather tired tonight.*

Weds. 10th. *At home, I put a quilt in to the frame today. Mrs. Hoyt came and she helped me place the batten. Martha came up tonight.*

Thurs. 11th. *At home. Martha and Helen came up today. Martha helped me quilt.*

Fri. 12th. *At home, we finished the quilt today. I had an apple bee tonight.*

Diary of Maria M. Fifield, 1860–61, Salisbury, New Hampshire

Ann Daggs, *Appliqué Quilt*

In the ornamentation of one's home, be it a mansion or a cottage, a regal suite of apartments or a tiny room, the clever woman takes advantage of what is pretty, popular, and suitable for the purpose.

Unsuspected real genius may abide in her own brain until called forth by the inspiration derived from augmenting the natural sweetness of her home by the dainty creations of acknowledged art. Then indeed, through her awakened ambition, will her home become a veritable "house beautiful."

Herbert M. Ross, *The Art of Drawing and Painting,* 1892

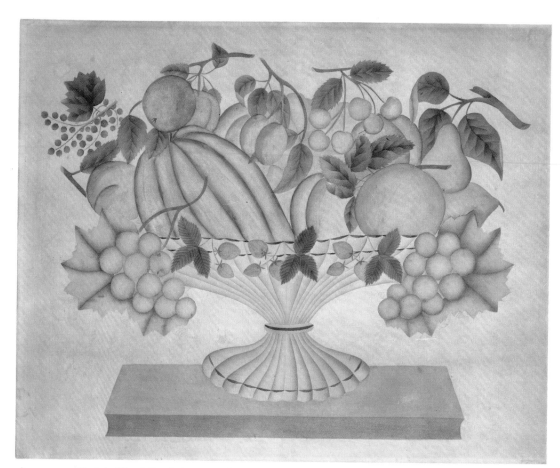

Anonymous, *Fruit in Fluted Bowl,* theorem painting

Theorem Painting: . . . It is better shaped to fruits, birds, and butterflies, than to landscapes and heads. It will enable you to paint on paper, silk, velvet, crepe, and light-colored wood.

Lay the theorem on the paper on which you intend to paint. . . . Press the theorem firmly down with weights at each corner, and proceed to paint.

Commence with a leaf; take plenty of paint, a very little moist, on your brush, and paint in the cut leaf of the theorem. . . . if successful with a leaf, try a grape.

Levina Urbino and Henry Day, *Art Recreations,* 1868

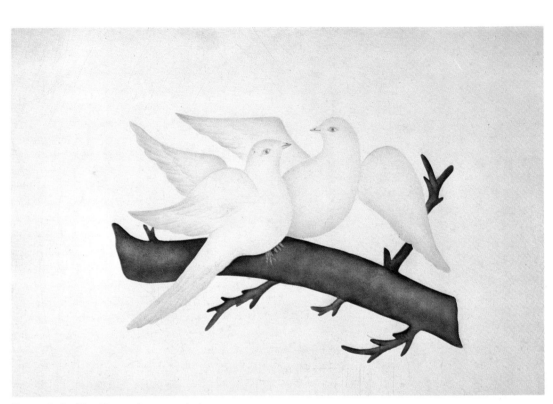

Emma Cady, *Two Doves,* theorem painting

To Paint on Velvet: Select firm white cotton velvet. Use paints a little more moistened.

Levina Urbino and Henry Day, *Art Recreations,* 1868

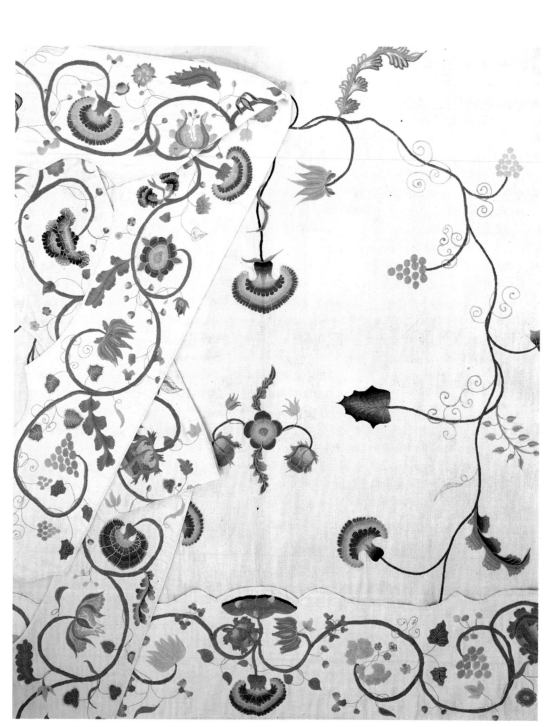

Anonymous, *Bed Hangings,* crewel embroidery

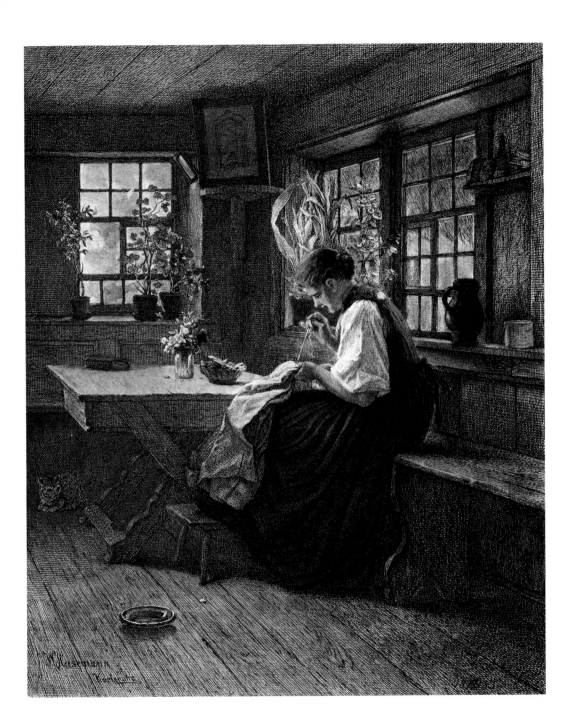

Patience is bitter, but its fruit is sweet.

Lida Clarkson, "Brush Studies," *Ladies' Home Journal*, May, 1884

1851

January. . . . *I have little opportunity to record thought or feelings, for want of opportunity to think. —I am always surrounded with a flock of noisy children, and my head resounds with their noise like an empty barrel—*

Friday [March 28]. . . . *made an effort to get on my much talked of quilt,— but with no assistance, it was very laborious, and I was almost sorry I undertook it—The children not quite so happy as yesterday, and troubled me much,— did not quite finish it, excessively tired; too much so to sleep well.*

Saturday [March 29]. *Oh what a constant round of sweeping & dusting, sweeping & dusting, the year round! I get weary of it, & wish I might never see another broom sometimes. And many little cares, almost distract me. I tried to finish the quilt, but was prevented. . . .*

Thursday A.M. [April 24]. *—All my scattering moments, are taken up with my needle.*

Saturday [April 26]. *Elizabeth & I spent most of the day in sewing, and accomplished quite a satisfactory days work. What a busy set of heads and hands to direct and control. Sometimes, I think I shall faint and fall down by the way.*

Diary of Ellen Birdseye Wheaton

24 January 1862. . . . *why feel like a beggar, utterly humiliated and degraded when I am forced to say I need money? I cannot tell, but I do; and the worst of it, this thing grows worse as one grows older.*

 Money ought not to be asked for, or given to a man's wife as a gift. Something must be due her, and that she should have, and no growling and grumbling nor warnings against waste and extravagance, nor hints as to the need of economy, nor amazement that the last supply has given out already. What a proud woman suffers under all this, who can tell?

Diary of Mary Boykin Chesnut

My mind is so cumbered with a deluge of little corroding cares that all I can think about is what shall we eat and what shall we drink and wherewithal shall we be clothed. My leanness! My leanness!

Diary of Mary Richardson Walker, 1848

I'd rather piece as eat, and I'd rather patch as piece, but I take natcherally delight in quiltin' . . . Whenst I war a new-married woman with the children round my feet, hit 'peared like I'd git so wearied I couldn't take delight in nothing; and I'd git ill to my man and the children, and what do you reckon I done them times? I just put down the breeches I was patchin' and tuk out my quilt squar'. Hit wuz better than prayin', child, hit wuz reason.

Aunt Cynthy, ca. 1900

It took me more than twenty years, nearly twenty-five, I reckon, in the evenings after supper when the children were all put to bed. My whole life is in that quilt. It scares me sometimes when I look at it. All my joys and all my sorrows are stitched into those little pieces. When I was proud of the boys and when I was downright provoked and angry with them. When the girls annoyed me or when they gave me a warm feeling around my heart. And John, too. He was stitched into that quilt and all the thirty years we were married. Sometimes I loved him and sometimes I sat there hating him as I pieced the patches together. So they are all in that quilt, my hopes and fears, my joys and sorrows, my loves and hates. I tremble sometimes when I remember what that quilt knows about me.

Marguerite Ickis, quoting her great-grandmother

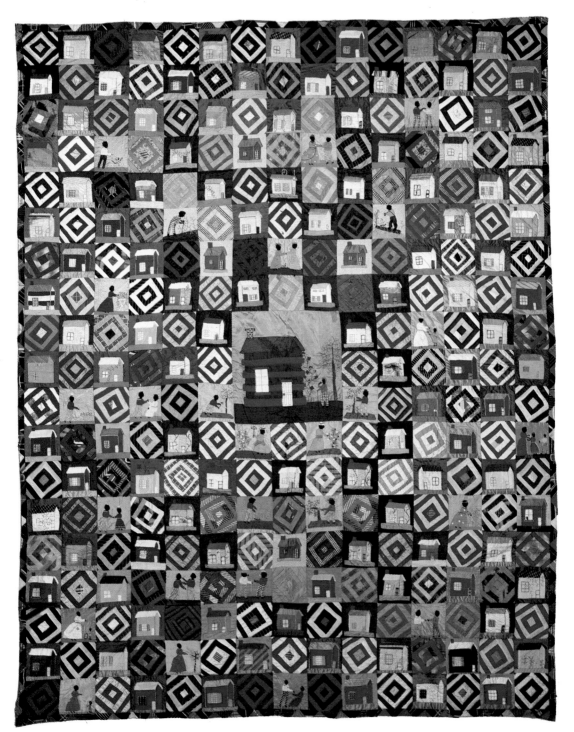

Anonymous, *Crazy City Quilt*

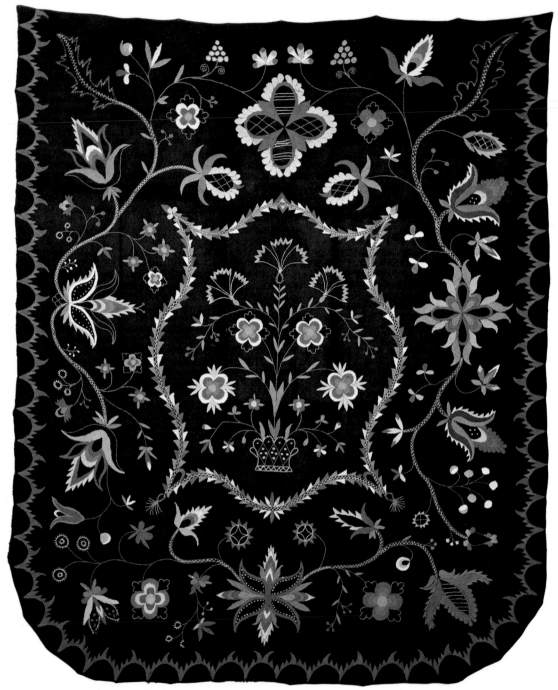

Anonymous, *Coverlet,* crewel embroidery

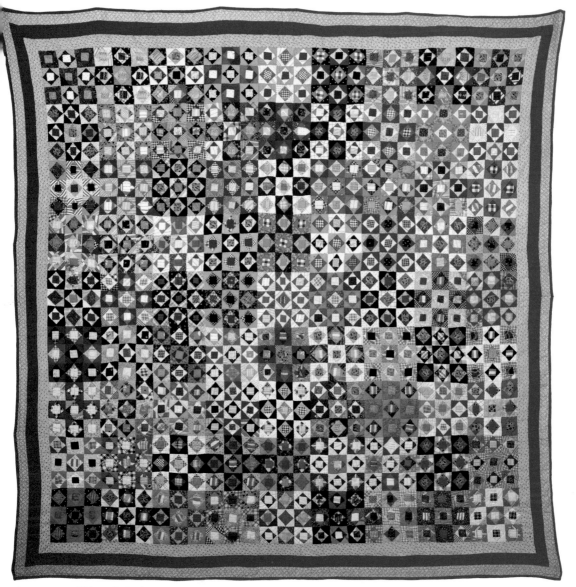

Anonymous, *"Mosaic" Quilt*

March 11, 1838. *Early Wednesday morning I was awoke with a great distress at my heart. My children's soul seemed to be such a burden to me that I found myself weeping. I got out of bed and knelt down but was not able to feel happy for some time since that time—Sarah has recovered but Maria is still ill. What I am yet to go through I know not, but God does—I hope I shall bear it without a murmur.*

March 20, 1838. *Have just heard of the Death of a child in the family. This is the third since December. They have all been very sudden. They are loud calls to the living. . . .*

<div align="right">Diary of Mrs. William W. Todd, 1837–1839</div>

Photo: Todd Smith

Anonymous, *To the Memory of Mrs. Mary Grouton . . . ,* painting on silk

Nov. 5, 1895. *Monday—We have laid father by mother's side. Everybody is so glad for him, but the agony comes all night and the tears the first thing in the morning. When mother went, we had him still.*

<div align="right">Diary of A. M. Libby</div>

March 6, 1836. *Before her confinement . . . she had a remarkable dream. . . .*

She thought she had been painting her own likeness; she had a most excellent likeness, the eyes looked like real life. While she was looking and admiring it, suddenly the eyes closed. She felt surprised and called her husband; she said she certainly drew them open. She dreamed they both fell on their knees.

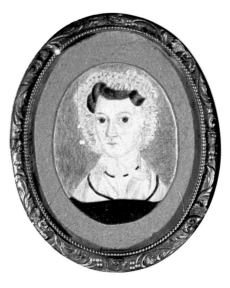

Deborah Goldsmith, *Self Portrait,*
ivory miniature

March 16th, 1836. *Deborah is still alive. . . . Her powers of speech have failed, her swallowing more difficult. . . . I ventured to ask her if she still felt if the Lord was with her; her countenance brightened, she nodded her head, and said, "yes."*

She died at half past three in the afternoon. Her father came about noon. She knew him. Her sister Ann's husband called a short time before death. She tried to raise her hand to shake hands, which was too much; I steadied it. Her eyes followed him when he went out.

This was the last act of consciousness. We discovered her breathing altered, no groan or struggle . . . she appeared to die easy. . . . I think it was the night before her death she spoke to her husband of the value of her hope. What would all the world be in comparison with it now?

Signed, Ruth Miner Goldsmith

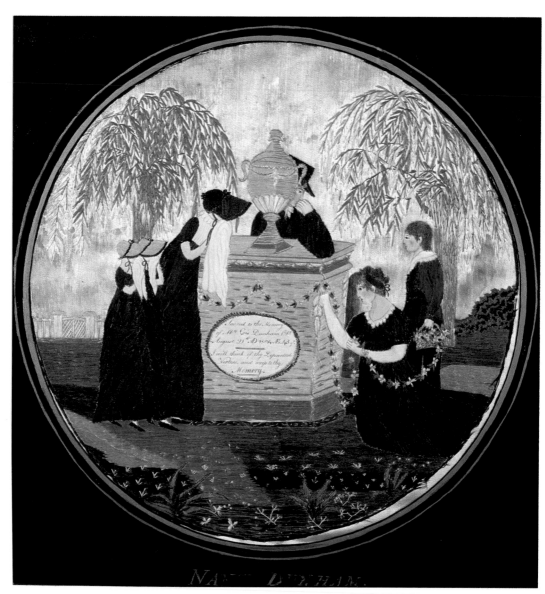

Nancy Dunham, *Sacred to the Memory of Mrs. Lois Dunham* . . . , needlework and paint

Sept. 19, 1869. *Warm & dry. My dear wife is dying. O, my Father, help me to be reconciled to this painful disposition of thy providence. Be with me & support me, & give me fortitude to bear my heart rending bereavement with due submission to thy will. Let me not sink in despair.*

Sept. 21, 1869. *Cloudy, signs of rain. A sad day, the saddest of my life. My wife, this day, is buried.*

Jan. 24, 1873. *My dear departed, most beloved—*

If departed spirits have knowledge of what happens here, you know how lonesome I am. My life, since your departure, has been one of sorrow that no earthly power can charm away. . . . I imagine you present, & seeing the lines I write. But, O, the terrible doubts that haunt me as to your real existence, & as to the immortality of the soul! . . . Are poor mortals left here to suffer, forgotten by departed friends in the heavenly world? Have you no memory of your bereaved & broken hearted husband?

Journal of Zadoc Long

1818

I am now a Widow, I have no bosom friend to go to in seasons of perplexity for advice, no one with whom I can unreservedly share all my griefs and Sorrows, all my Joys and pleasures.

. . . I did love him, alas but too tenderly—we lived together on such terms as man and wife ought to live, placing perfect confidence in each other, bearing one another's burdens and making due allowances for human imperfection.

Diary of Sarah Ripley Stearns

Feb. 1, 1848. *Rain all day. This day my dear husband, my last remaining friend, died.*

Feb. 2, 1848. *Today we buried my earthly companion. Now I know what none but widows know; that is, how comfortless is that of a widow's life, especially when left in a strange land, without money or friends, and the care of seven children. Cloudy.*

Mrs. Elizabeth Dixon Geer Smith, Diary Written on the Oregon Trail, 1847–48

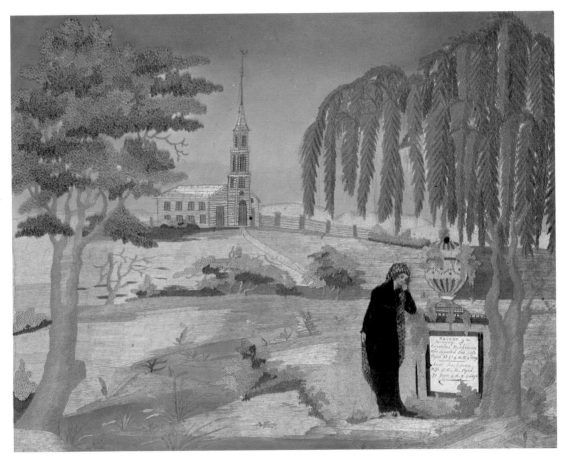

A. D. Beekman, *SACRED to the Memory of Gerardus Beekman* . . . , needlework

Remember Me

Because she walks in a humbler path, shall not that path have flowers?

John P. Brace, Address to the students of Litchfield Academy, October 28, 1816

I reckon everybody wants to leave somethin' behind that'll last after they're dead and gone. It don't look like it's worth while to live unless you can do that.

Aunt Jane of Kentucky, ca. 1900

I honor every woman who has strength enough to step out of the beaten path when she feels that her walk lies in another, strength enough to stand up and be laughed at, if necessary.

. . . But in a few years it will not be thought strange that women should be preachers and sculptors, and every one who comes after us will have to bear fewer and fewer blows.

Harriet Hosmer in *Daughters of America*, 1883

Angels now are hovering round us
Unprocevd thay mix the throng
Wondering at the love that crownd us
Glad to joyn the holy Song

Mary Ann Willson, *Three Angels' Heads,* watercolor

ELIZA BELL'S ACCOUNT BOOK

5th month 21st 1890. *I commenced this comforter for a present to the President of the United States, Benjamin Harrison as a specimen of the needle work of an American Lady. The colors are blue and old rose and all of American Manufacture.*

Eliza H. Bell 5/31 This day I am 77 years

Cape May 7th Month 10th 1890. *It contains fourteen yards—It has* one hundred and thirty nine yards of straight work. *Twelve yards of* Chain-work. *One square yard of* Small Shells *in the centre. Thirty three Feathers. Ten Stars.—*
I commenced quilting it 5th mo 21st 1890 and finished it on the "4th of July" the most glorious Anniversary in our nation's history.
During that time I was absent from home ten days.
Every stitch done by my own hand, and the needle was threaded 777 times, entirely by myself.
My 77 birthday was on the 31st day of 5th mo. 1890.

Eliza H. Bell

August 28 1890, *Cape May Point.*

My dear Madam.
. . . The gift I value very highly since so much good will as well as deft work are to be seen in it. What this warm covering is to the body in winter, that and more the esteem and commendation of unselfish and patriotic people like you, dear Madam, is to one who in the discharge of his public duties, cannot hope to escape much unfriendly criticism.
With the very sincere wish that all your days may be full of serenity and joy.
I am sincerely your friend
Benjamin Harrison

A HISTORY OF PINCUSHIONS

I commenced making them soon after the "War" for the soldiers who had served so faithfully to preserve the Union which they succeeded in doing as we can now testify.

Since that time I have mostly kept an account, and have made 2,600 up to this date—having distributed them to high and low rich and poor colored people and Indians in many of the States where I have travelled. "Benjamin Harrison" the President of the United States, Gen Louis Wagner, "Wagner's Island" being named after him—and "Alexander Bell" the great "Telephone" gentleman, have each received one of them, all expressing their pleasure in having these useful little mementoes of remembrance.

I always fill them with pins (mostly from Clement & Bloodgoody store) and no doubt I have used a million for this purpose—more perhaps than any other woman in the "United States" have given to the public, which has been a great source of pleasure to me, always feeling "It is more blessed to give than to receive."

Eliza H. Bell 4th mo 10th 1891

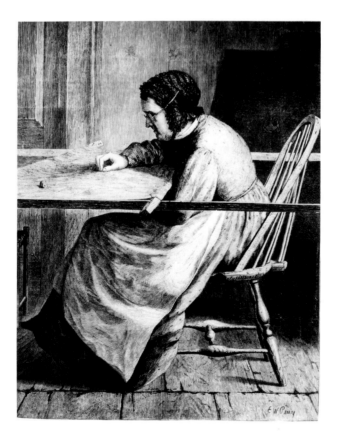

SHAKER GIFT OFFERING

"Basket of Apples"

Come, come my beloved
And sympathize with me
Receive the little basket
And the blessing so free

Sabbath. P.M. June 29th 1856. *I saw Judith Collins bringing a little basket full*
of beautiful apples for the Ministry, from Brother Calvin Harlow and Mother
Sarah Harrison. It is their blessing and the chain around the pail represents
the combination of their blessing. I noticed in particular as she brought them to
me the ends of the stems looked fresh as though they were just picked by the
stems and set into the basket one by one.

Seen and painted in the City of Peace by Hannah Cohoon

Come, come my beloved
And sympathize with me
Receive the little basket
And the blessing so free

Sabbath 5 P. M. June 29th 1856.
I saw Judith Collins bringing a little basket full of beautiful apples,
for the Ministry, from Father Calvin Harlow and Mother Sarah Harrison.
It is their blessing and the chain around the basket represents
the combination of their blessing. I noticed in particular as
she brought them to me the ends of the stems looked fresh
as though they were just picked by the stems, and set into
the basket one by one. Seen and painted in the City of Peace.
by Hannah Cohoon.

Hannah Cohoon, *Spirit Drawing*, watercolor

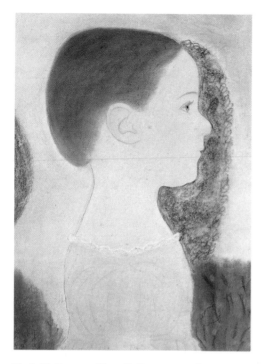 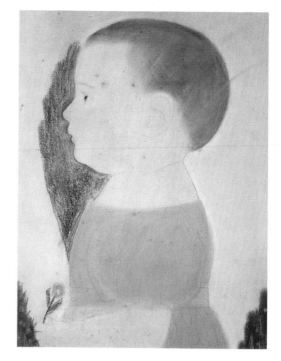

Ruth H. Bascom, *Mary E. Denny*, pastel Ruth H. Bascom, *Charles A. Denny*, pastel

1828

Feb. 5 Tues. *Clear and warm like spring. Much of the little snow went off or became thin, not much on the turnpike but sleighs run on back roads. Mr. and Mrs. Stephen Jones came in chaise and passed two hours here to see Harriet's likeness and pronounce it good.*

Oct. 11. *fair til 5 PM then some thunder and lightening and a shower. . . . Mrs. Wiswell and 2 children here. I painted all day and yesterday AM on their 2 faces and put them in frame at night.*

8 Nov. *Mrs. Austin brot home first washing (1 doz.) towards paying for her likeness—a good bargain.*

1829

Oct. 30. Athol. *Mr. Bragg called for me to take a likeness of Mr. David Kendall deceased, for a profile, remembrance &c., which I prepared to the best of my ability.*

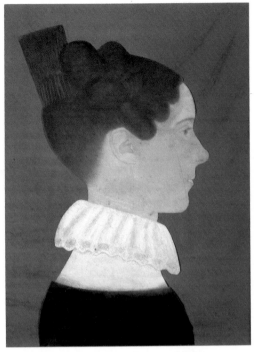

Ruth H. Bascom, *Mary D. Denny*, pastel

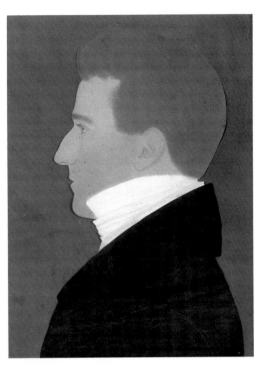

Ruth H. Bascom, *Joseph A. Denny*, pastel

1837

6 July. *Painted on little Mary Denny.*

1839

23 Feb. *Rev. Annah Allen came in* AM *& sat for the last time for his copy which I finished* PM *& he came at eve & took it, paid for glass & frame &c. $1—the rest gratis.*

1841

25 June. *completed Edwin's sketch again and that of my late friend E.L.B. which is designed for Elvira P. Philbrick, and is considered a great resemblance or an accurate one.*

<div align="right">Diary of Ruth Henshaw Bascom</div>

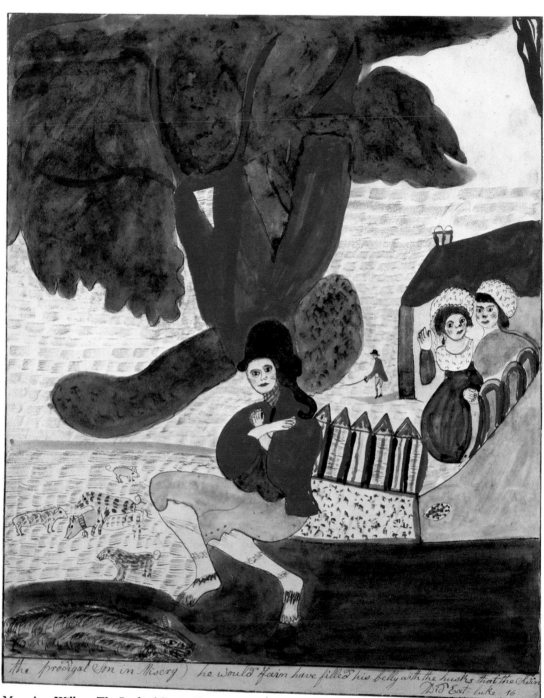

Mary Ann Willson, *The Prodigal Son in Misery,* watercolor

The artist, Miss Willson and her friend, Miss Brundage, came from one of the eastern States and made their home in the town of Greenville, Greene County, New York. They bought a few acres and built, or found their house, made of logs, on the land. Where they resided many years. One was the farmer (Miss Brundage) and cultivated the land by the aid of neighbors, occasionally doing some ploughing for them. This one planted, gathered in, and reaped, while the other (Mary Ann Willson) made pictures which she sold to the farmers and others as rare and unique "works of art."—Their paints, or colours, were of the simplest kind, berries, bricks, and occasional "store paint" made up their wants for these elegant designs.

These two maids left their home in the East with a romantic attachment for each other and which continued until the death of the "farmer maid." The artist was inconsolable, and after a brief time, removed to parts unknown.

The writer of this often visited them, and takes great pleasure in testifying to their great simplicity and originality of character—their unqualified belief that these "pictures" were very beautiful . . . (they certainly were), boasting how greatly they were in demand. "Why! They go way to Canada and clear to Mobile!"

The reader of this will bear in mind that nearly fifty years have passed since these rare exhibits were produced . . . and now, asking no favors for my friends, (as friends they were), let all imperfections be buried in their graves and shield these and them from other than kindly criticism. . . .

Letter from "An Admirer of Art," ca. 1850

January 13, 1850. *Woman is an allegory; a myth sleeping in a myth; a sheathed goddess and a blazonry; a Sphinx's riddle, devouring and devoured; an ambush and retirement, a nimbleness, a curiosity, a veil behind a veil, and a peeping forth from behind veils; a crypt of coyness, a gaol of surprises, and an ambuscade.*

Bronson Alcott, father of Louisa May

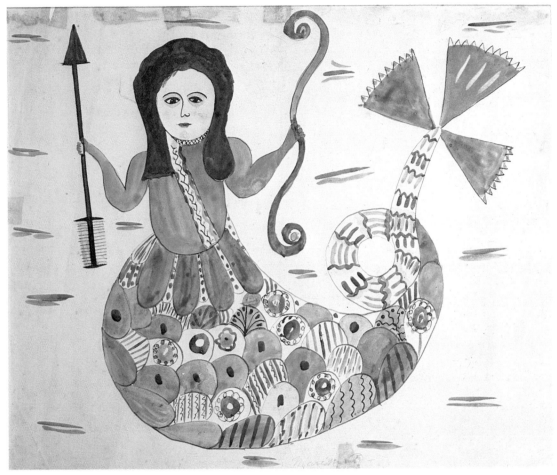

Mary Ann Willson, *Marimaid,* watercolor

1891

I found the owner, a negro woman, who lived in the country on a little farm whereon she and her husband made a respectable living. . . .

Last year I sent her word that I would buy it if she still wanted to dispose of it. She arrived one afternoon in front of my door in an ox-cart with the precious burden in her lap encased in a clean flour sack, which was still enveloped in a crocus sack.

She offered it for ten dollars, but I told her I only had five to give. After going out consulting with her husband she returned and said, "Owin' to de hardness of de times, my ole man lows I'd better teck hit." Not being a new woman she obeyed.

After giving me a full description of each scene with great earnestness, she departed but has been back several times to visit the darling offspring of her brain.

She was only in a measure consoled for its loss when I promised to save her all my scraps.

Jennie Smith

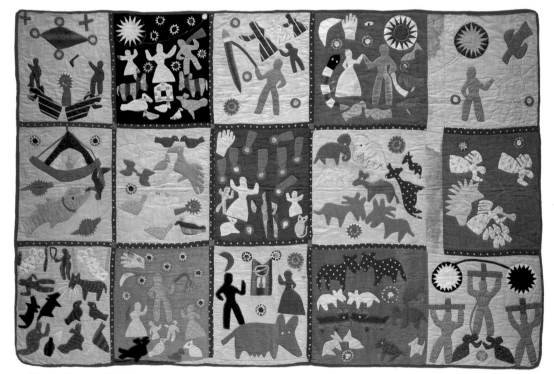

Harriet Powers, *Bible Quilt*

Harriet Powers' explanation of Bible Quilt squares *(from top, left to right)*:

1. *Job praying for his enemies. Jobs crosses. Jobs coffin.*
2. *The dark day of May 19, 1780. The seven stars were seen 12. N. in the day. The cattle all went to bed, chickens to roost and the trumpet was blown. The sun went off to a small spot and then to darkness.*
3. *The serpent lifted up by Mosses and women bringing their children to look upon it to be healed.*
4. *Adam and Eve in the garden. Eve tempted by the serpent. Adam's rib by which Eve was made. The sun and moon. God's all seeing eye and God's merciful hand.*
5. *John baptising Christ and the spirit of God descending and rested upon his shoulder like a dove.*
6. *Jonah cast over board of the ship and swallowed by a whale. Turtles.*
7. *God created two of every kind, male and female.*
8. *The falling of the stars on Nov. 13, 1833. The people were frighten and thought that the end of time had come. God's hand staid the stars. The varmints rushed out of their beds.*
9. *Two of every kind of animals continued. Camels, elephants, "gheraffs" lions, etc.*
10. *The angels of wrath and the seven vials. The blood of fornications. Seven headed beast and 10 horns which arose out of the water.*
11. *Cold Thursday, 10. of Feb. 1895. A woman frozen while at prayer. A woman frozen at a gateway. A man with a sack of meal frozen. Isicles formed from the breath of a mule. All blue birds killed. A man frozen at his jug of liquor.*
12. *The red light night of 1846. A man tolling the bell to notify the people of the wonder. Women, children and fowls frightened but Gods merciful hand caused no harm to them.*
13. *Rich people who were taught nothing of God. Bob Johnson and Kate Bell of Virginia. They told their parents to stop the clock at one and tomorrow it would strike one and so it did. This was the signal that they had entered everlasting punishment. The independent hog which ran 500 miles from Ga. to Va. her name was Betts.*
14. *The creation of animals continues.*
15. *The crucifixtion of Christ between the two thieves. The sun went into darkness. Mary and Martha weeping at his feet. The blood and water run from his right side.*

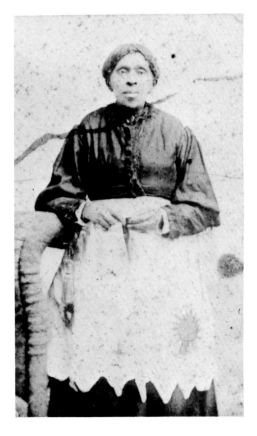

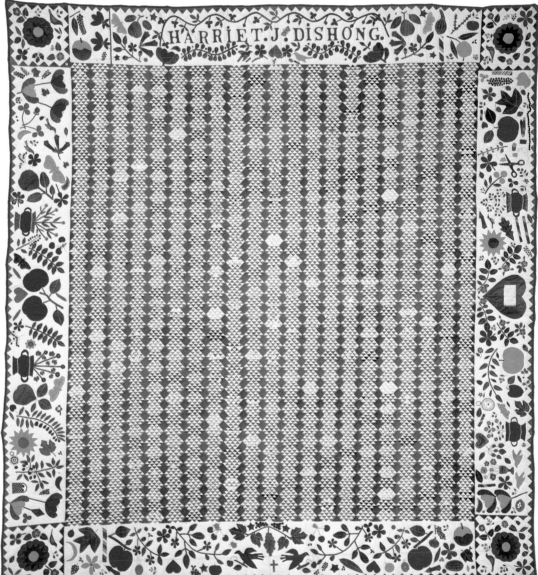

Harriet Dishong, *Pieced & Appliqué Quilt*

I've been a hard worker all my life, but 'most all my work has been the kind that "perishes with the usin'," as the Bible says. That's the discouragin' thing about a woman's work . . . if a woman was to see all the dishes that she had to wash before she died, piled up before her in one pile, she'd lie down and die right then and there. I've always had the name o' bein' a good housekeeper, but when I'm dead and gone there ain't anybody goin' to think o' the floors I've swept, and the tables I've scrubbed, and the old clothes I've patched, and the stockin's I've darned. . . . But when one of my grandchildren or great-grandchildren sees one o' these quilts, they'll think about Aunt Jane, and, wherever I am then, I'll know. I ain't forgotten.

Aunt Jane of Kentucky, ca. 1900

When this you see, Remember me
And bear me in your mind.
What others say when I'm away
Speak of me as you find.

Old sampler verse

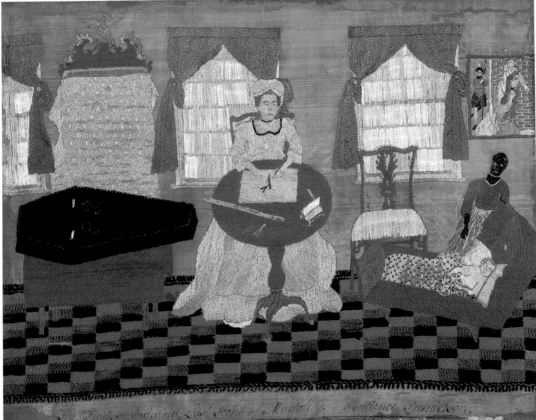

Prudence Punderson, *The First, Second and Last Scene of Mortality*, needle picture

A BIOGRAPHICAL NOTE

The work of certain writers and artists appears frequently in *Anonymous Was A Woman*. Among the writers, some, like Louisa May Alcott (1832–1888), Catherine E. Beecher (1800–1878), and her sister Harriet Beecher Stowe (1811–1896), were professional authors with an enthusiastic public. For the most part, however, the diarists and letter writers represented here were non-professionals. They include young girls and matrons, suitors and fathers. Like Mary Richardson Walker (1811–1897), a missionary wife who kept a diary of her stormy honyemoon trip West and her married life in frontier Oregon, and Zadoc Long (1800–1873), a man who lovingly recorded family life and daily events in his journal, they were simply people with a natural gift for writing deeply-felt, unembellished prose.

A few of the artists, too, achieved a degree of professional recognition in their communities. Both Mary Ann Willson (active ca. 1810–1825), an original painter of watercolors and Harriet Powers (1837–1911), a former slave famous for her visionary "Bible" quilts, accepted payment for their work—Willson gladly and with obvious pride, Powers only grudgingly and out of extreme financial hardship. Yet neither pursued her art as a vocation. One who did was Susan Waters (1823–1900). Her lifelong career as a successful painter began at age fifteen when she did drawings for her natural history class to help pay her tuition at the local female seminary. Another, Deborah Goldsmith (1808–1836), was a self-taught itinerant "limner" who executed most of her luminous water color portraits in the four years prior to marrying her client, George Throop. The obligations of marriage and family generally took precedence over professional artistic pursuits. Certainly this was true in the case of Sarah Perkins (1771–1831) and Prudence Punderson (1758–1784), young artists of great promise whose works all pre-date their marriages.

Only a few married women, like Ruth Henshaw Bascom (1772–1848) and Eunice Pinney (1770–1849) managed to flourish as artists throughout the most demanding years of family life. Bascom mentions her cut-paper and pastel profiles in her diary and notes her gratification at the occasional payment she received. The diary itself is a monumental document, spanning fifty-seven years of her life, and Bascom remains unique in having combined the skills of an artist with the habits of a diarist. Eunice Pinney's whimsical compositions, prized masterworks of American primitive painting, were created for her own pleasure and, occasionally, served as models for her daughter's pupils at a girls' school in Virginia.

Though a number of the diaries and correspondences are now published, and many of the art works now command high prices among connoisseurs and collectors, it is significant that in their own day these writers and artists worked almost exclusively to satisfy the requirements of their own hearts.

LIST OF COLOR ILLUSTRATIONS

Frontispiece, Barbara Becker (1774–1850), *Taufschein for Elias Hamman*. Shenandoah Co., Virginia, 1806. 15″ x 12½″. From the Collection of Mr. and Mrs. William E. Wiltshire III. *p. 8*, Eunice Pinney (1770–1849), *Farm Scene With Two Fashionable Ladies*. Connecticut, ca. 1815. 12½″ x 15″. Painted on the back of a letter to her daughter. (*Courtesy Sotheby Parke Bernet*) *p. 15*, Anonymous, *Scene in a Garden*. American, after 1815. Copied from an engraving by Prot, after Rousseau. From the Collection of Old Sturbridge Village, Sturbridge, Massachusetts. *p. 18*, Sarah Perkins (1771–1831), *Lucy Perkins (1783–1820)*. Connecticut, ca. 1790. 19¾″ x 15¼″. (*Courtesy Connecticut Historical Society*) *p. 21*, Louisa Williams, age 14, *Pieced and Appliqué Quilt, Bursting Cubes*. 1862. 91″ x 91″. America Hurrah Antiques, New York City. (*Photograph from The Quilt Engagement Calendar, courtesy E.P. Dutton*) *p. 25*, Anonymous, *Woman With Sheep*. American, late 18th century. 20″ x 18¼″. New York Historical Society, New York City. *pp. 26–27*, Mary Trumbull (1745–1831). *Needlework picture, over-mantel size*. ca. 1765. 20¾″ x 51⅝″. (*Courtesy Connecticut Historical Society*) *p. 29*, Anna Pope (1784–1826), *Sampler*. 1796. 16″ x 21¾″. Collection of Betty Ring. *p. 31*, Cynthia Burr (b. May 21, 1770), *Sampler*. Providence, Rhode Island. 1786. 16½″ x 14½″. Museum of Art, Rhode Island School of Design. (*Photograph Courtesy of The Magazine Antiques*) *p. 32*, Mary Batchelder, *Sampler*. Newburyport, Massachusetts, 1773. 16¼″ x 11″. (*Courtesy Cooper Hewitt Museum of Design*) *p. 33*, Mary Antrim (1795–1844), *Sampler*. 1807. 17″ x 16¾″. Collection of Betty Ring. *p. 35*, Esther Coggeshall (1764–d. young) *Sampler: "EC in my 11th year AD 1774–"*. Newport, Rhode Island. (*Courtesy Connecticut Historical Society*) *p. 38*, Mary Cushing West and Lucy Hammatt West, *The Artist and Cupid*. Tiverton, Rhode Island, first half of the nineteenth century. 13½″ x 11″. From the Collections of the Worcester Historical Museum, Worcester, Massachustts. *p. 39*, Anonymous, *The Watercolor Class*. American, ca. 1815–1820. (*Courtesy of the Art Institute of Chicago*) *p. 40*, Abby Eddy, *Aurora*. American, 1813. 23¼″ x 27¼″. Collection of the Newark Museum, Newark, New Jersey. *p. 41 (top)*, Hannah Crowninshield, *Pompey, the "Cleopatra's Barge" Cat*. Salem, Massachusetts, 1817. 7″ x 4½″. Peabody Museum, Salem, Massachusetts. *p. 41 (bottom)*, Ellen Holt (b. 1843), *Edith*. Andover, Massachusetts, ca. 1855. 7″ x 8″. North Andover Historical Society, North Andover, Massachusetts. *p. 42*, Eliza Greening, *Abraham and Isaac*. New England, ca. 1815. 16″ x 18⅜″. From the Collections of the Worcester Historical Museum, Worcester, Massachusetts. *p. 43*, Mary Green (1788–1817), *Liberty*. Massachusetts, 1804. 23¼″ x 16⅞″. Embroidered picture after the print of the same title by Edward Savage, 1796. Worcester Art Museum, Worcester, Massachusetts. *p. 44*, Hannah Clapp, *Clapp Memorial*. 1809. 22″ x 20¼″. Collection of Betty Ring. *p. 45*, Sarah Lawrence, *Picture of a Young Girl*. Concord, Massachusetts, ca. 1810. 14½″ x 11⅛″. (*Courtesy Phyllis and Louis Gross*) *p. 49*, Deborah Goldsmith (1808–1836), *Miss Catherine N . . .* Portrait from Goldsmith's second album, 1829–1832. 5¾″ x 6″. Collection of Dan Throop Smith. *p. 51*, Eunice Pinney (1770–1849), *Cupid's Arrow*. Connecticut, ca. 1810. 5½″ x 7¼″. (*Photo Courtesy Sotheby Parke Bernet*) p. 55, Pieced by Miss Ella L. Platt, *Friendship Quilt*. New York City, ca. 1875. 84″ x 68″. Twenty squares of different designs with makers' names or initials, made by twenty young ladies as an engagement present for Frank H. Platt. The New York Historical Society, New York City. *p. 56*, Elizabeth Glaser, *Lady in a Yellow Dress Watering Roses*. Maryland, ca. 1830. 9¾″ x 7¾″. From the Collection of Mr. and Mrs. William E. Wiltshire III. *p. 58*, Deborah Goldsmith (1808–1836), *The Silesian Girl*. 1831. 6″ x 6″. Collection of Professor Dan Throop Smith. *p. 61*, Eunice Pinney (1770–1849), *The Courtship*. Connecticut, ca. 1815. 12½″ x 9¼″. (*Courtesy Mr. and Mrs. Erving Wolf*) *p. 64*, Signed, Sarah A. Shafer, *Album Bride's Quilt*. Baltimore, 1850. 103″ x 105″. America Hurrah Antiques, New York City. *p. 67*, Maryan Smith, *The Tow Sisters*. Pennsylvania, 1854. 14¾″ x 12″. From the Collection of Mr. and Mrs. William E. Wiltshire III. *p. 68*, Anonymous, *The Chandler Wedding Tapestry*. New England, 1756. 20½″ x 14¾″. American Antiquarian Society. *p. 71 (top)*, Sarah Perkins (1771–1831), *Dr. Caleb*

Perkins (1749–1819). 19¾″ x 15¼″. (*Courtesy Connecticut Historical Society*) *p. 71 (bottom)*, Sarah Perkins (1771–1831), *Mrs. Caleb Perkins (b. 1745)*. 19¾″ x 15¾″. (*Courtesy Connecticut Historical Society*) *p. 73*, Deborah Goldsmith (1808–1836), *Sarah Stanton Mason Throop*. 1831. 5″ x 6″. Collection of Professor Dan Throop Smith. *p. 77*, Anonymous, *Album Friendship Quilt*. New York State, ca. 1840. 110″ x 114″. A "sampler" quilt showing the work of many different women. America Hurrah Antiques, New York City. *p. 78*, Anonymous, *Baby's Quilt*. ca. 1885. 44″ x 35″. America Hurrah Antiques, New York City. *p. 81*, Eunice Pinney (1770–1849), *Two Women*. Connecticut, ca. 1815. 11″ x 14⅜″. New York State Historical Association, Cooperstown, New York. *p. 82*, Attrib. Susan Waters (1823–1900), *Child With Rocking Horse*, ca. 1850. 40⅝″ x 27″. National Gallery of Art, Washington, D.C. Gift of Edgar William and Bernice Chrysler Garbisch. *p. 86*, Ann Daggs, *Quilt*. Rochester, New York, 1818. 84″ x 78″. America Hurrah Antiques, New York City. . . *p. 88*, Anonymous, *Fruit in Fluted Bowl*. American, mid-nineteenth century. National Gallery of Art, Washington, D.C. Gift of Edgar William and Bernice Chrysler Garbisch. *p. 89*, Emma Cady (1854–1933), *Two Doves on a Branch*. East Chatham, New York, ca. 1890. 10⅛″ x 15″. (*Courtesy Abby Aldrich Rockefeller Collection*) *p. 90*, Anonymous, *Headcloth and Valences*, American, 1730–1790. (*Courtesy Henry Francis du Pont Winterthur Museum*) *p. 95*, Anonymous, *Crazy City Quilt*. New Jersey, ca. 1870. Log Cabin variation, 76″ x 62″. An important example of black folk art, the quilt contains more than 100 houses and many panels depicting activities of daily life. Thomas K. Woodard: American Antiques & Quilts. (*Photograph from* The Quilt Engagement Calendar, *courtesy E.P. Dutton*) *p. 96*, Anonymous, *Coverlet*. New England, 1815–1825. 100″ x 84″. Thomas K. Woodard: American Antiques & Quilts. (*Photograph from* The Quilt Engagement Calendar, *courtesy E.P. Dutton*) *p. 97*, Anonymous, *Mosaic Quilt*. Pennsylvania, ca. 1870. (*Courtesy Rea Goodman Quilt Gallery, Inc.*) *p. 98*, Anonymous, *Mourning Piece*. American, early 19th century. Worcester Art Museum, Worcester, Massachusetts. *p. 99*, Deborah Goldsmith (1808–1836), *Self Portrait*. 1833. 2¼″ x 2″. Collection of Professor Dan Throop Smith. *p. 100*, Nancy Dunham (1792–1860), *Mourning piece*. Colchester, Connecticut, 1804. Memorial for the mother of the artist. (*Courtesy Connecticut Historical Society*) *p. 103*, A. D. Beekman, *Mourning piece*. Early nineteenth century. 17¼″ x 22″. New York Historical Society, New York City. *p. 107*, Mary Ann Willson (active ca. 1810–1825), *Three Angels Heads*. Greene Co., New York. Museum of Fine Arts, Boston, Massachusetts. *p. 111*, Hannah Cohoon (1788–1864), *A Little Basket of Beautiful Apples*. Hancock, Massachusetts, 1856. 10⅛″ x 8³⁄₁₆″. From the collections of Shaker Community, Inc., at Hancock Shaker Village, Pittsfield, Massachusetts. *p. 112 (right)*, Ruth (Henshaw) Bascom (1772–1848), *Charles Addison Denny, (1836–1914)*. Massachusetts, 1837. 16″ x 12″. Worcester Art Museum, Worcester, Massachusetts. *p. 112 (left)*, Ruth (Henshaw) Bascom (1772–1848), *Mary Elizabeth Denny, (1834–1924)*. Massachusetts, 1837. 16″ x 12″. Worcester Art Museum, Worcester, Massachusetts. *p. 113 (left)*, Ruth (Henshaw) Bascom (1772–1848), *Mary (Davis) Denny, (1806–1899)*. Massachusetts, ca. 1839. 20″ x 15⅛″. Worcester Art Museum, Worcester, Masachusetts. *p. 113 (right)*, Ruth (Henshaw) Bascom (1772–1848), *Joseph Addison Denny (1804–1875)*. *Massachusetts, 1839. 20″ x 15″.* Worcester Art Museum, Worcester, Massachusetts. *p. 114*, Mary Ann Willson (active ca. 1810–1825), *The Prodigal Son in Misery*. Greene Co., New York. 10⅛″ x 12½″. National Gallery of Art, Washington, D.C. Gift of Edgar William and Bernice Chrysler Garbisch. *p. 117*, Mary Ann Willson (active ca. 1810–1825), *Marimaid*. Greene Co., New York. 13″ x 15½″. New York State Historical Association, Cooperstown, New York. *p. 118*, Harriet Powers (1837–1911), *Bible Quilt*. Georgia, ca. 1900. Cotton appliqué. Museum of Fine Arts, Boston, Massachusetts. *p. 120*, Harriet J. Dishong, *Pieced and Appliqué Quilt*. 94½″ x 88½″. Made with the assistance of her sister Mrs. Mary E. Dishong, near McConnellsburg, Fulton County, Pennsylvania. The quilt was started in 1875 and completed March 20, 1890. The quilt contains over 22,640 pieces. America Hurrah Antiques, New York City. *p. 123*, Prudence Punderson (1758–1784), *The First, Second and Last Scene of Mortality*. Preston, Connecticut, ca. 1775. 12⅝″ x 16¹¹⁄₁₆″. (*Courtesy Connecticut Historical Society*)

SELECTED BIBLIOGRAPHY

PUBLISHED SOURCES

The published sources not included in this selection are identified in the main body of the text.

Alcott, Louisa May. *Louisa May Alcott: Her Life, Letters and Journals.* Edited by Ednah Dow Cheney. Boston: Little, Brown & Co., 1928.

An Admirer of Art. Letter about Mary Ann Willson in Jean Lipman and Alice Winchester, *Primitive Painters in America, 1750–1950.* New York: Dodd & Mead, 1950.

Aunt Cynthy, in Elizabeth Daingerfield, "Patch Quilts and Philosophy," *The Craftsman,* vol. 14, 1908.

Bascom, Ruth Henshaw. "Diaries" in Clara E. Sears, *Some American Primitives.* Boston, 1941.

Cavé, Mme. Elizabeth. *Drawing from Memory.* New York: G. P. Putnam & Sons, 1868.

Chesnut, Mary Boykin. *Diary From Dixie.* Edited by Ben Ames Williams. New York: D. Appleton & Co., 1905.

Fuller, Elizabeth. "Diary" in Francis Edward Blake, *History of the Town of Princeton, Massachusetts, 1715–1915.* Princeton, Massachusetts, 1915.

Geer, Mrs. Elizabeth Dixon Smith. "Diary Written on the Oregon Trail in 1847," *Oregon Pioneer Association Transactions,* 1907.

Goldsmith, Deborah and Ruth Miner Goldsmith and George Throop, in Olive Cole Smith, *The Old Traveling Bag.* Privately printed, 1934.

Green, Mary, "Letter to Doct. John Green" in Stephen B. Jareckie, "The Early Republic: Consolidation of Revolutionary Goals," Worcester Art Museum, 1976.

Hall, Eliza Calvert. *Aunt Jane of Kentucky.* Boston: Little, Brown & Co., 1908.

Hanaford, Phebe A. *Daughters of America.* Augusta, Maine: True & Co., 1882.

Havens, Catherine Elizabeth. *Diary of a Little Girl in Old New York.* New York: Henry Collins Brown, 1920.

Ickis, Marguerite. *The Standard Book of Quiltmaking and Collecting.* New York: Dover, 1960.

Kull, N. W. " 'I Can Never Be Happy There In Among So Many Mountains'—The Letters of Sally Rice", *Vermont History,* 38 (winter, 1970).

Long, Zadoc. *From the Journal of Zadoc Long, 1800–1873.* Edited by Pierce Long. Caldwell, Idaho: The Caxton Printers, Ltd., 1943.

Orr, Lucinda Lee. *Journal of a Young Lady of Virginia, 1781–1782.* Baltimore: J. Murphy and Company, 1871.

Richards, Mrs. Caroline Cowles. *Diary of Caroline Cowles Richards, 1852–1872.* Canandaigua, New York, 1908.

Smith, Jennie in Gladys-Marie Fry, "Harriet Powers: Portrait of a Black Quilter," *Missing Pieces: Georgia Folk Art 1770–1976.* Exhibition catalogue, edited by Anna Wadsworth, Georgia Council of the Arts and Humanities, 1976.

Vanderpoel, Emily Noyes, comp. *Chronicles of a Pioneer School from 1792 to 1833, being the history of Miss Sarah Pierce and her Litchfield School.* Cambridge, Massachusetts: University Press, 1903.

———. *More Chronicles of a Pioneer School from 1792–1833, being added history on The Litchfield Female Academy kept by Miss Sarah Pierce and her nephew John Pierce Brace.* New York: The Cadmus Bookshop, 1927.

Walker, Mary Richardson. *Mary Richardson Walker: Her Book.* Edited by Ruth Karr McKee. Caldwell, Idaho: The Caxton Printers, Ltd., 1945.

Wheaton, Ellen Birdseye. *Diary of Ellen Birdseye Wheaton, 1816–1858.* Privately published by Louise Ayer Gordon. Boston: D. B. Updike, the Merrymount Press, 1923.

UNPUBLISHED SOURCES

Bascom, Ruth Henshaw. "Diaries, 1789–1846," 52 octavo volumes. American Antiquarian Society, Worcester, Massachusetts.

Bell, Eliza. "Account Book, 1888–1891" of Bayside, Long Island. Courtesy Henry Francis du Pont Winterthur Museum, Joseph Downs Manuscript Collection, Winterthur, Delaware.

Brown, Olive. "Letter to Sabrina Bennett, May 15, 1839" in the exhibition *Young Women in New England,* summer, 1977. Old Sturbridge Village, Sturbridge, Massachusetts.

Chaplin, Eliza. "Letter to Laura Lovell, July 28, 1820." Eliza (Chaplin) Nelson Letters 1819–1869. Essex Institute Library, Salem, Massachusetts.

Clark, Isaac. "Letter to his Daughter, 11th September, 1806. Brewster," in the exhibition *Evidence of Accomplishment: Schoolgirl Art in New England,* summer 1977. Old Sturbridge Village, Sturbridge, Massachusetts.

Fifield, Maria M. "Diary, 1860–1861" of Salisbury, New Hampshire. Courtesy Henry Francis du Pont Winterthur Museum, Joseph Downs Manuscript Collection, Winterthur, Delaware.

Libby, A. M. "Diary, 1871–1900" of Lewiston, Maine. New York Historical Society, New York City.

Stearns, Sarah Ripley. "Diaries, 1801–1805, 1808–1818" of Greenfield, Massachusetts. Stearns Collection, Schlesinger Library, Radcliffe College, Cambridge, Massachusetts.

Todd, Mrs. William W. "Diary, 1837–1839," of New York City. New York Historical Society, New York City.

Tucker, Mary Orne. "Diary, 1802" of Haverhill, Mass. Essex Institute Library, Salem, Massachusetts.

Van Schaack, Catherine. "A Journal for the Summer of 1809—written at Miss Pierce's School, Litchfield, Conn." New York Historical Society, New York City.

ADDITIONAL SOURCES

Dewhurst, C. Kurt, Betty MacDowell and Marsha MacDowell. *Artists in Aprons: Folk Art by American Women.* New York: E.P. Dutton in association with the Museum of American Folk Art, New York, 1979.

Rothman, Ellen K. "A Most Interesting Event: The Decision to Marry in New England, 1790–1850." January 24, 1975. (Ph.D. dissertation in progress, Brandeis University.)

Saxton, Martha. *Louisa May: A Modern Biography of Louisa May Alcott.* New York: Avon Books, 1977.

Welter, Barbara. "The Cult of True Womanhood: 1820–1860," *American Quarterly 18* (summer, 1966).